MIT LIST VISUAL ARTS CENTER
May 8–July 12, 2009

CONTEMPORARY ARTS MUSEUM HOUSTON
October 17, 2009–January 17, 2010

MATTHEW DAY JACKSON THE IMMEASUR- ABLE DISTANCE

ACKNOWLEDGEMENTS

We are delighted to present *Matthew Day Jackson: The Immeasurable Distance* at the MIT List Visual Arts Center and to publish the artist's work in this book. It has been both a pleasure and a privilege to have Matthew Day Jackson as an artist-in-residence at MIT over the past year, and to see the results of some of his research here embodied in the works in this exhibition. Many on the faculty and staff of MIT were helpful to the artist during his time at MIT, but we particularly wish to thank Richard Amster, Director of Facilities, Campus Planning, Engineering, and Construction; Eric Beaton, Energy Manager; Ron Adams, Senior Electrical Engineer of MIT's Facilities Department from MIT Energy Initiative; David Mindell, Director of MIT's Program in Science, Technology, and Society; Deborah G. Douglas, Curator of Science and Technology for the MIT Museum; Richard Perdichizzi, Senior Technical Instructor in Aeronautics/Astronautics at the MIT Wright Brothers Wind Tunnel; Greg Tucker, Director of Facilities of MIT's Media Lab; and Jerome I. Friedman, Institute Professor Emeritus. We are also deeply indebted to Florence and Philippe Ségalot, Alexandra and Steven Cohen, and the Saatchi Gallery, London, for lending works by the artist that are crucial to this exhibition.

We appreciate the contributions that Bill Arning, Deborah G. Douglas, David Mindell, Tom Morton, and David Tomkins made to this catalogue; and that Dominic Hall, Curator, Warren Anatomical Museum at Harvard University, agreed to give a lecture in conjunction with the show. Peter Blum and Simone Subal of the Peter Blum Gallery in New York, NY, also have been extremely generous with their time and support for this exhibition, as well as Ruth Phaneuf and Nicole Klagsbrun of the Nicole Klagsbrun Gallery in New York City.

The catalogue was designed by AHL&CO and we thank them very much for their work on this project. Support for this exhibition has been provided by the Council for the Arts at MIT, the Massachusetts Cultural Council, and the Phoenix Media/ Communications Group. Generous support from the Nimoy Foundation made Jackson's residency at MIT possible, and we extend our very sincere thanks to them.

Many thanks must go to Bill Arning, curator of this exhibition for his efforts for this exhibition as well as for all of his many valuable contributions during his nine-year tenure at the List. I also would like to thank Philip Khoury, MIT's Associate Provost and Ford International Professor of History for his continuing support of the List Visual Arts Center and its programs. We are very grateful to List Center Advisory Committee member Marjory Jacobson for her very generous help with this project; and I particularly thank List Center staff members David Freilach, Tim Lloyd, John Rexine, Mark Linga, John Osorio-Buck, Patricia Fuller, John Gianvito, and Barbra Pine and all of the preparators and gallery attendants for their work on this exhibition as well. I also must express our gratitude to List Center interns Ana Cintra, Grace Goodrich, Helen Indorf, Judith Klausner, Shalini Patel, and Megan Willis for their willing and very capable help with the catalogue and the exhibition.

Our deepest thanks are extended to Matthew Day Jackson for his cooperation during every stage of this project and for his unflagging efforts in producing this exhibition and catalogue.

—Jane Farver, *Director*, MIT List Visual Arts Center

I would like to add my words of thanks to those of Jane Farver. All of those she has thanked I feel compelled to thank as well. This exhibition is a direct result of it having begun at MIT, which is the most extraordinary place to have worked as a curator. Not only was I privileged to have developed many relationships with great minds from many diverse disciplines over the last nine years, I got to accompany many visionary artists during their residencies, and witness future technologies in their prototype forms. Standing in labs alongside some of the greatest visual artists of our time I saw the possibilities of these potentially world-changing inventions through their eyes. I leave MIT convinced that all creativity—be it in science, technology or art—springs from the same source and that it is only in the dialog between disciplines that the most creative thinking takes place—a reality that became a theme in Jackson's work as well. Jackson might have been the most enthusiastic of our Nimoy artists-in-residence and the discussions he had at the Institute were amazingly lively. I thank the artist for letting me be part of his creative process.

As well as my many colleagues at MIT already thanked above, I must thank Jane Farver herself for all the opportunities I was afforded here and all she taught me by example of how to direct a museum. I am putting her lessons into practice daily in my new position.

On behalf of the Contemporary Arts Museum Houston, I would like to express my gratitude to the Brown Foundation, Inc., of Houston, which has continued its generous support of our publications program. I am also particularly appreciative of the support we have received from our donors to the Museum's Major Exhibition Fund.

The staff at CAMH has already been amazing to work with, and I so look forward to seeing this exhibition in the CAMH space installed with their tremendous sensitivity and expertise. Jackson has already worked with the staff of CAMH as a participating artist in Toby Kamps's award-winning exhibition *The Old, Weird America*, and both the artist and the folks at CAMH have let me know that they are eager to work together again. I look forward to many more collaborations between the MIT List Visual Arts Center and Contemporary Arts Museum Houston in the future.

—Bill Arning, *Director*, Contemporary Arts Museum Houston

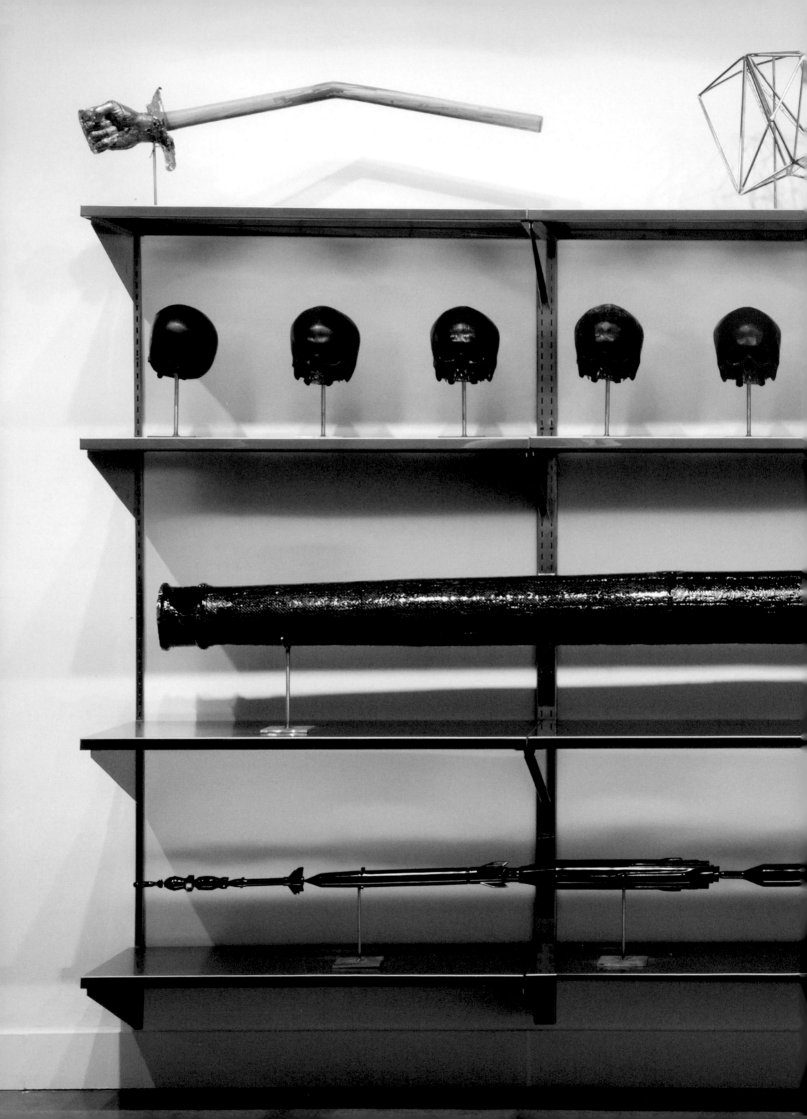

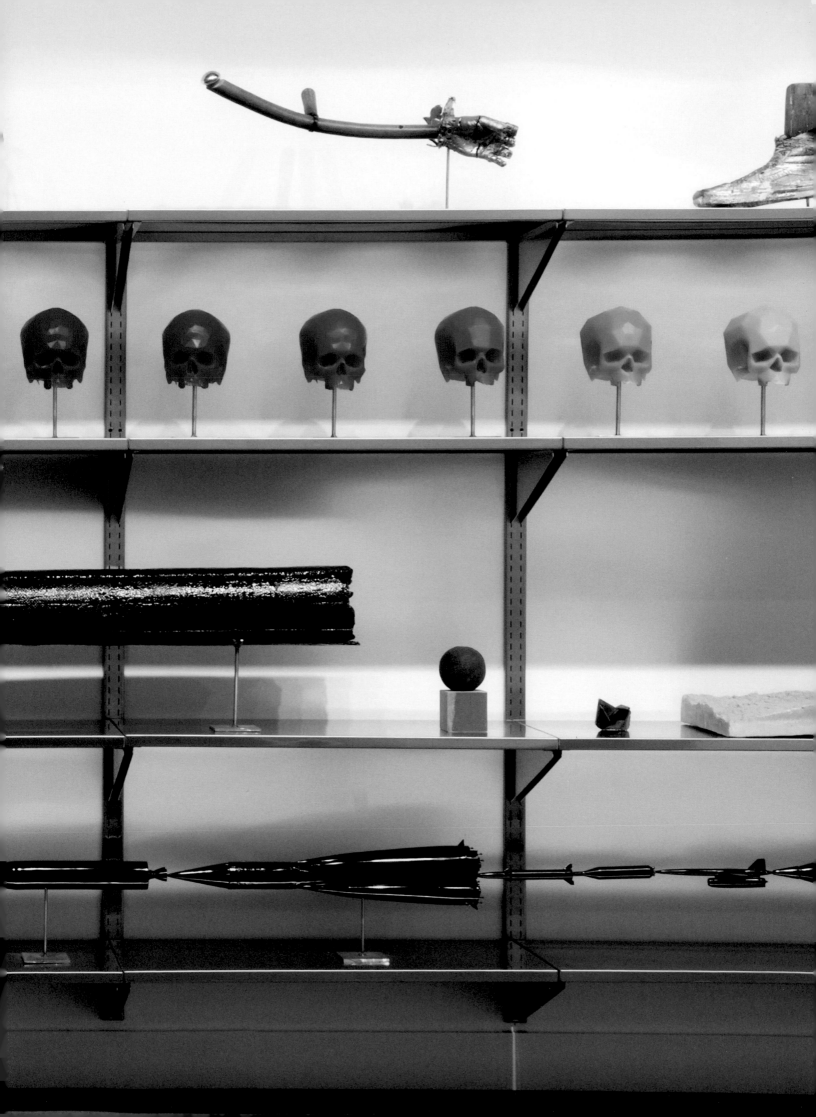

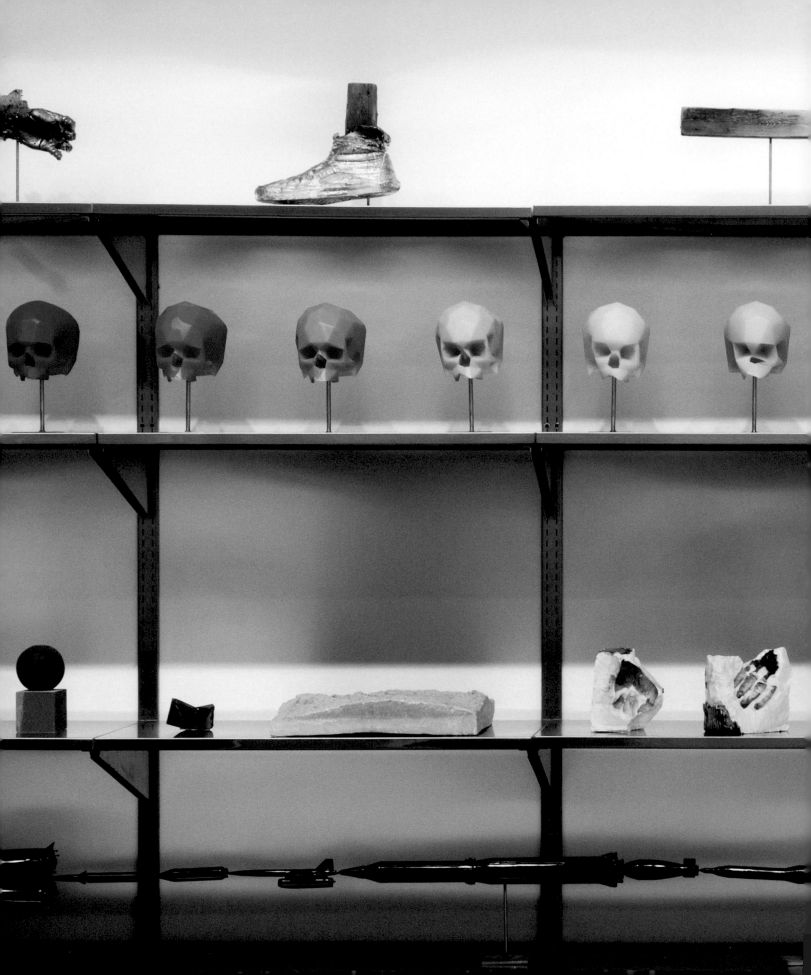

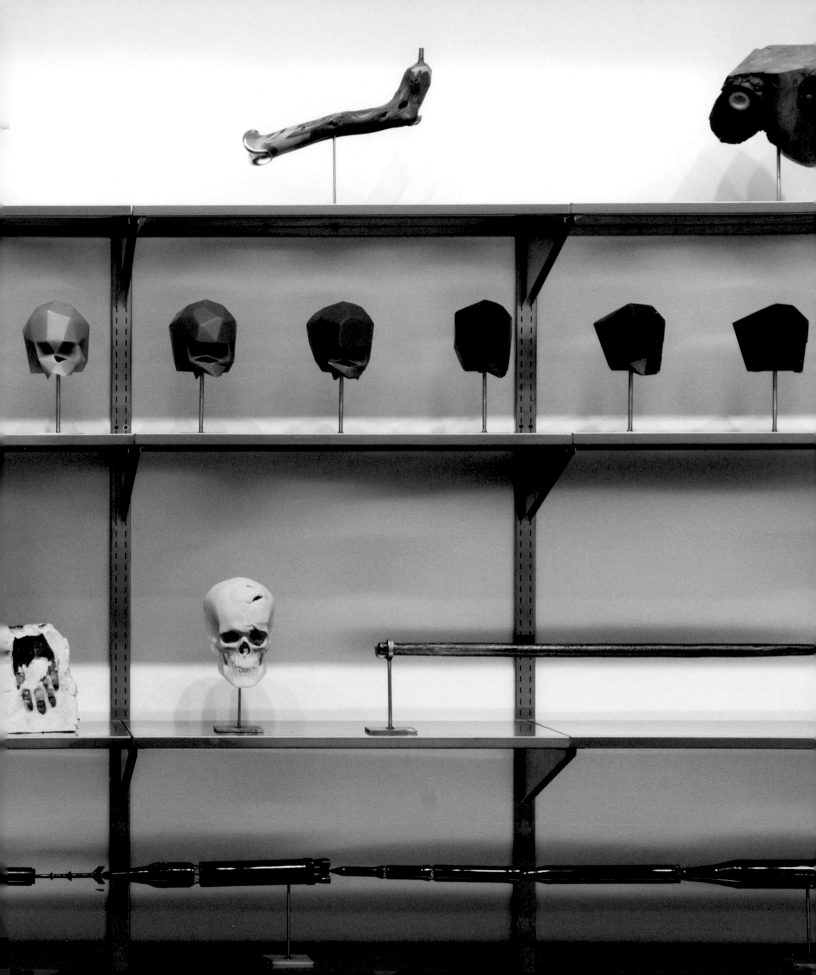

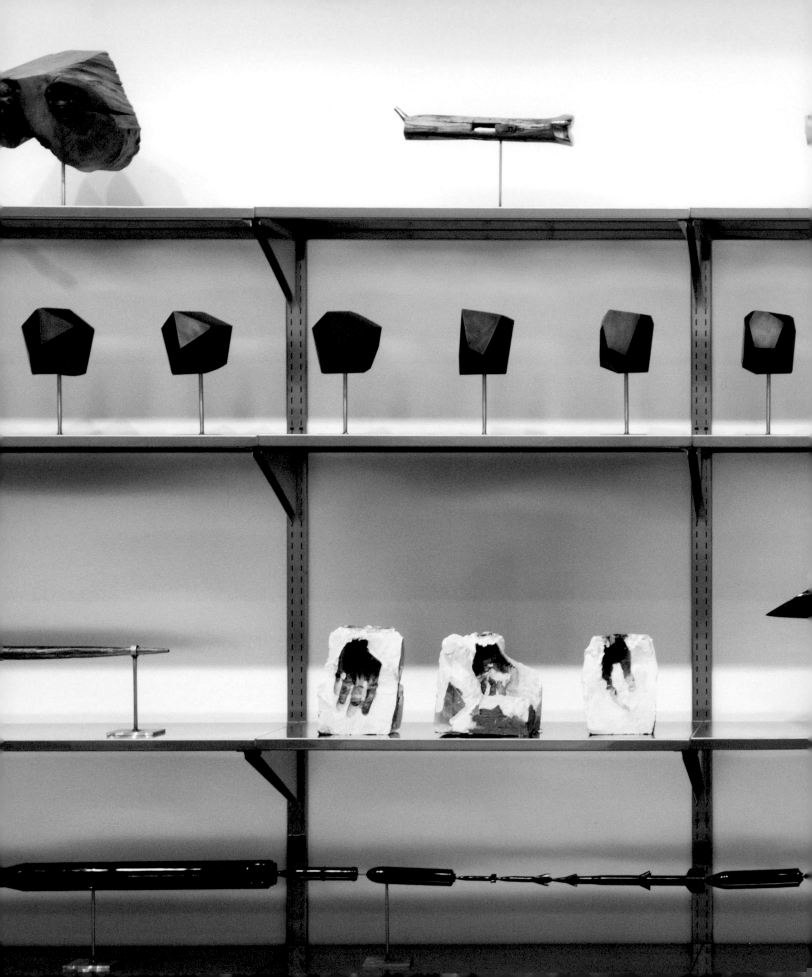

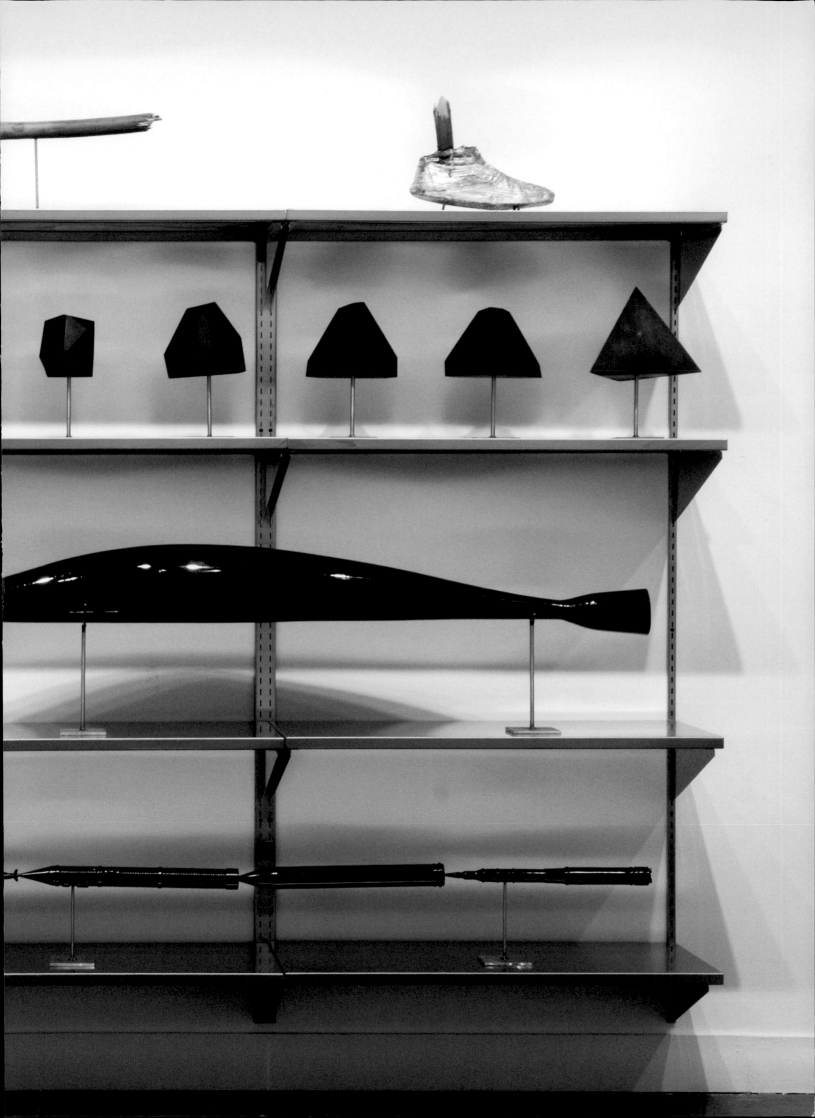

Matthew Day Jackson and
Karen Jackson
*Untitled (A Mother's Prayer
for Her Son)*, 2005
Color DVD
13 minutes, 15 seconds

MATTHEW DAY JACKSON: THE IMMEASURABLE DISTANCE

Bill Arning

Matthew Day Jackson: The Immeasurable Distance presents works based on Jackson's research as an artist-in-residence at MIT, with a selection of earlier works that demonstrates the artist's affinities for such an institution. Jackson's histories and hagiographies are manifested in sculptures, constructed paintings, objects, books, and videos.

The materials and forms of Jackson's visually powerful objects have meanings that require some decoding in order to fully grasp their narratives and implications. Jackson, unafraid of engaging the biggest issues imaginable, gives himself the task of the mythmaker who weaves together, in the form of apprehensible narratives and images, the most uplifting and terrifying events of the twentieth century.

Jackson investigates human consciousness and how positive evolutionary developments in human thought and culture occur under physical or mental stress. He explores how constructive and destructive technological developments stem from the same impetus to expand human experience, prove something to be possible, and achieve progress, whatever the risk. Drag racing, the Apollo space missions, test-pilot culture, Utopian spiritual movements, and the nuclear legacy commingle with iconic nineteenth- and twentieth-century figures like visionary Buckminster Fuller, drag racer Big Daddy Don Garlits…even the artist's mom who appears as a loving mother giving a blessing to her son's exhibition on video. Jackson tells these stories as modern myths, with his players as mischievous tricksters. Like all myths, their retelling re-inscribes cultural values and gives form to a collective imagination. Jackson's considered representations of them just might allow a new idea of what it means to live at a time when technology has rewritten the basic precepts of philosophy and religion.

Stress—the body and mind pushed past their previous limits—can produce beautiful thinking, including world-saving concepts that may spring from the depths of human despair. Such stress—physical or spiritual—can produce scientific discoveries that can be applied for constructive, destructive, or morally ambiguous ends. It is hard to predict what forms they may take from the specific circumstances of their genesis. The purest and most progressive thoughts may contain seeds of apocalypse, while weapons can be repurposed for peaceful ends. Human hubris, folly, and ego fuel the building of the civilization and the making of art, yet they have also unlocked a Pandora's box of dangers. The differences between competition and cooperation become increasingly impossible to discern in the race for greater achievements. No venue could be more appropriate for a first presentation of works interrogating this situation than MIT, where the positive and negative applications of science and technology are in a complex, century-long dance.

Jackson has an intense interest in the history of manned space travel. Today, manned space travel can seem to be a legend from an earlier, more heroic era, especially for an artist like Jackson, born in the middle of the 1970s, when the Apollo missions were coming to a close, to be replaced by the far less romantic, if equally perilous, space shuttle missions. The artist is working in a political period in which the captivating vision of a better future embodied in the Apollo program might reemerge into human consciousness and affect daily political and social realities.

Space shuttle missions have been eminently practical affairs, the massive expense of which is justified by their importance in enabling humans to perform scientific experiments and fix expensive satellites in space, above the terrestrial realm of atmosphere and gravity. Their intention was to normalize space travel and, after a rocky start and a few deadly disasters, they have done so. But their useful period is largely past and they soon will be retired. The thought of having no access to space is harmful in terms of how mankind envisions its place in existence.

The MIT presentation of this exhibition occurs during the Institute's celebration of the fortieth anniversary of the Apollo 11 mission, scheduled for June 11 and 12, 2009. The surviving astronauts from Apollo 11 will convene at MIT for a public forum, at a time when the crucial symbolic function of manned space travel has reemerged in national politics. A collaborator on the conference and on *Matthew Day Jackson: The Immeasurable Distance* is science historian David A. Mindell from MIT's Program in Science, Technology, and Society whose 2008 MIT Press book *Digital Apollo* discusses how the technology for the mission was written to give the human astronauts a function as pilots—rather than as redundant passengers or as they derogatorily referred to the role they were assigned, "spam in a can."

In December of 2008, a team from MIT led by Mindell published a white paper on manned space travel including returning to the moon and working toward a future landing on Mars.[1] They argue that earlier justifications—the potential of useful scientific research, the impetus to develop new technologies, promoting scientific education—are inadequate given the expense and risk to human life (seventeen people have died in the space program). Instead, the team recommended a renewed program based on more poetic and intangible assets: exploration, national pride, international prestige, leadership, and expanding human experience.

In a period in which the younger generation is frequently convinced that all useful information and experience is available remotely on their computers if they just pick the right search engine, the space scholars needed to logically work through the

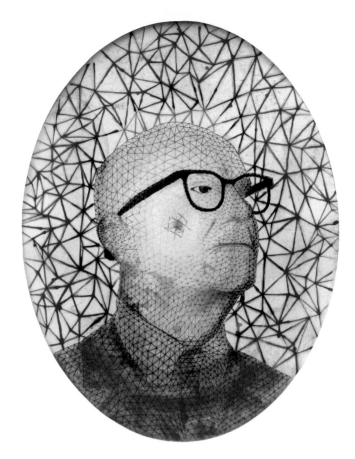

Bucky (ROYGBIV), 2007
Intaglio (soft ground and spit bite aquatint), screen-print
24 ¾ x 17 ½ inches, oval sheet

significance of humans "being there" in space while refuting the many spurious arguments that space enthusiasts have trotted out. The false claims include those based on an innate, irresistible human desire to explore and the fact that human fingers are more dexterous than any mechanical apparatus in performing experiments. In human history, exploration meant looking for better areas to live and encountering other cultures along the way. This is not the case with going into space, an exploration that is far from practical. Rather, exploration as manifested in the resumption of deep space manned travel is redefined by the authors as "an expansion of the realm of human experience, bringing people into new places, situations and environments, expanding and redefining what it means to be human."[2]

In the new political climate of the United States in 2009, in which concepts like "hope" and "change" seem able to have tangible effects, this argument might work (perhaps even in spheres beyond science, including the arts.) It is in this area—where technologies and dreams intersect—that Matthew Day Jackson is making his new works. Mindell and his team's white paper clearly describes how the U.S. can lead in this endeavor without creating or needing the distraction and waste of a new, competitive "space-race," like that which fuelled the race to the moon in the sixties. Competition, they argue, works but squanders resources and inhibits collaboration. The MIT report claims that a salient contribution of earlier manned spaced travel was the production of never-before-seen images of humans in space and on the surface of the moon.

Those powerful images cannot be replicated by unmanned exploration and they raised the ontological question of the relationship of human life to the particular planet Earth. In fact, those images along with the images showing the full sphere of the earth appearing small and fragile taken from the surface of the moon, ushered in many of the utopian dreams of the 1960s as well as the environmental movement. R. Buckminster Fuller—literally represented by Jackson in this exhibition in a saint-like portrait— used this new conception to persuasive effect with his rhetorical conceptualization of mankind as sharing a vessel he termed Spaceship Earth.[3]

While we can only imagine the implications of the future images that might be produced of humans arriving on Mars, walking on another planet for the first time, it is the 1969 Apollo 11 space voyage (the first mission to land a human on the surface of the moon), that is most deeply inscribed on the imagination of the public. This is also true for those born twenty years after the fact.

MIT developed the computer codes that brought the astronauts safely to the moon's surface–a 1,400-page document called *Luminary 1A*, and another called *Colossus*, which are in the collection of the MIT Museum.[4] The team that wrote the computer commands developed the rudiments of the code while working on the Polaris missile system. Thus the commands are an example of the reuse of weapons technology and the strange bedfellows that the scientific imperative desire to discover new possibilities can create, as many of the early computer-code writers came from the pacifist counterculture.

Within the codes are quotes from Shakespeare, quotations from the radical politics of the 1960s ("Burn Baby Burn"), and strange asides to the astronauts and future readers. In collaboration with the MIT Museum, the artist had the document digitally scanned and produced *Luminary 1A and Colossus (after Borges and The Library of Babel)* (2009), facsimiles of the codes in the form of antique-style books that appear as if they might contain a magician's spells or intricate legal codes.

Each book contains 410 pages, a reference to the books that inhabit the great library in Jorge Luis Borges' 1941 story *The Library of Babel*. In short, these volumes might constitute the beginnings of another wing of the Library of Babel. They are now available for viewers to peruse, and each reader will leave behind a tiny bit of him or herself—their natural skin oils on the absorbent paper. The vast majority of computer users today are happy to live in the wired, cyber world and care little about how codes are written. The idea that codes were once newly written by mortals and not received as divine writ seems especially obvious in these fragile pages.

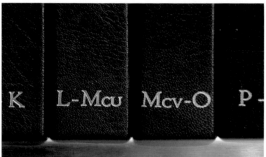

Luminary 1A and Colossus (after Borges and The Library of Babel), 2009
Ten volumes, leather and canvas, oil, dirt, blood, body fluids from the ungloved hands of its viewers over the span of its life as an artwork, gold, stainless steel
24 x 72 x 12 inches, installed

FOLLOWING LEFT
Study Collection, 2009 (Detail)
Skull metamorphosis

FOLLOWING RIGHT
Study Collection, 2009 (Detail)
Models of U.S./Soviet nuclear weapons

Jackson's *Study Collection* (2009) is an enormous stainless steel shelf-unit covered top to bottom with objects that appear to be maquettes that could be built larger or that function as small scale replicas whose viability could be experimentally tested—as two of the models were in the making of Jackson's video-based piece, *Little Boy and Fat Man* (2009). Jackson's decision to use the stacked shelves was inspired by his visits to the technological artifacts in the MIT Museum's basement storeroom, as well as the display of Buckminster Fuller's models in the Whitney Museum of American Art retrospective of Fuller's complex output as designer, architect, theoretician, and guru.[5]

Study Collection features models of both Soviet and U.S. nuclear weapons, including Little Boy and Fat Man and missile systems from V1, V2, Thor, Titan, and Cruise missiles. The model form brings to mind the aura of the scientist as a myopic boy controlling what he can from his room—unaware that his efforts are affecting the world outside. The scale models are conjoined in chronological order, conjuring the use of the biological term "evolution" as the constant metaphor for all technological developments even when the evolution leads toward machines that could usher in the apocalypse.

Study Collection also includes another series of sequential models that shows the artist's skull morphing into a tetrahedron, through a spectrum of colors. The spectrum is a recurrent theme in the artist's work; he is interested in how visible light evolved into human optic mechanisms as an optimal way to move through Earth's particular environment. It is therefore a way of knowing reality that is formed from local conditions; the spectrum is also circular, the last color (violet) adjoins the first (red), forming an eternal loop. This loop structures an animation by Jackson in which the skull evolves through the spectrum. In western cultures we tend to read left to right, and can see a progressive narrative in which the human traits of Jackson's skull are eliminated one by one until his head is a pure geometric solid form, rational and mystical at the same time.

The shelves also contain another famous skull, a replica of the scarred skull of Phineas Gage, an unfortunate railway-worker whose actual skull is in Harvard University's Warren Medical Museum. Gage forgot to mix sand with his gunpowder while tamping it into a drilled hole in rock being made ready for blasting. This caused an explosion that propelled his tamping iron through his eye socket and brain and up through the top of his skull. It destroyed much of the left hemisphere of his brain, and according to witnesses, landed 50 feet away. While this should have been a fatal wound, Gage was reported to have been chatting on the way to the hospital. He survived for eleven years but with an altered personality. Unemployable at his previous level,

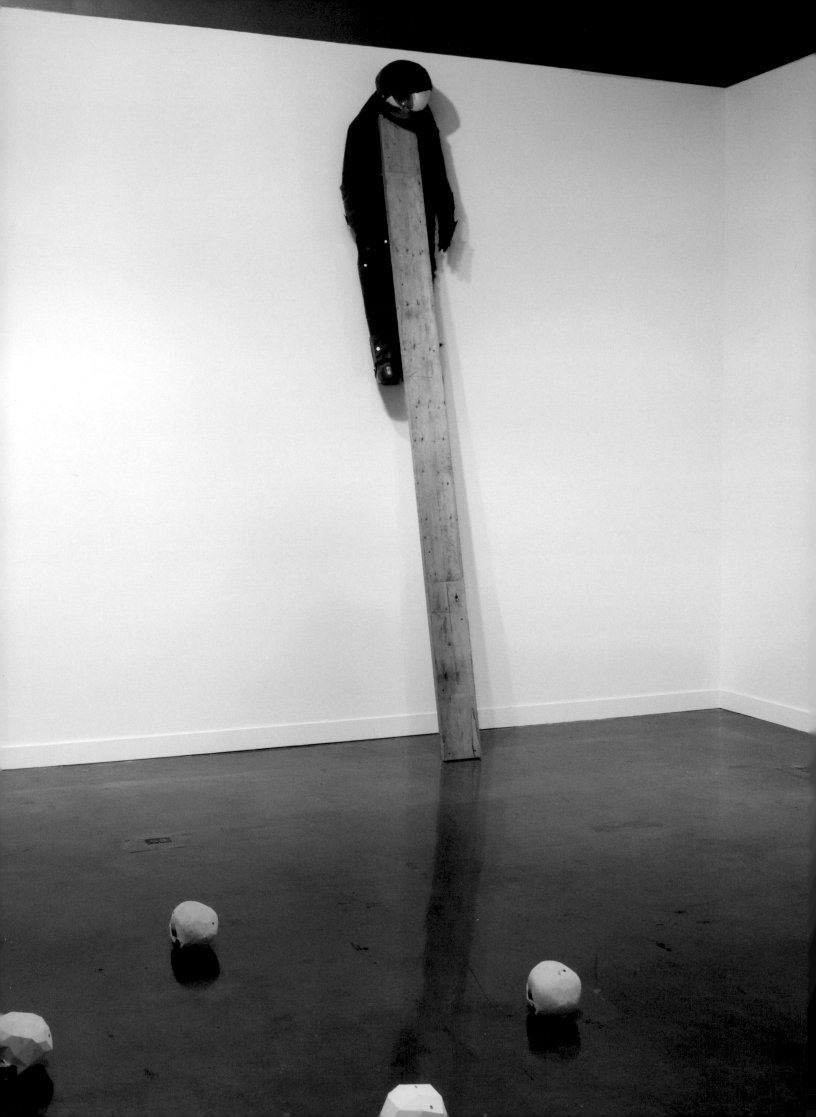

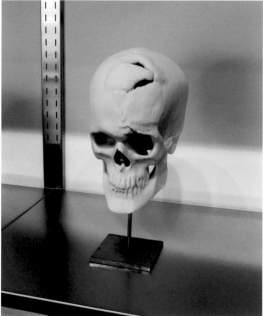

he appears to have lost all impulse control. In the beginning of the twentieth century, early brain-scientists were inventing means such as the lobotomy to surgically intervene in emotional and psychological problems. Gage's case was cited as proof that surgical intervention could be effective as a treatment, despite the fact that Malcolm MacMillan, the foremost expert on the case, points out that neither the actual areas of the brain destroyed nor the precise behavioral effects were recorded.[6] However, theoreticians and poets still employ the unfortunate Mr. Gage as an example of the physicality and embodiment of human emotions.[7]

The skull model is shown alongside a digital replica of the three-foot tamping iron that shot through Gage's skull making him a living oddity and example of the mind/body split. The rocket-like rod traveled with Gage throughout his life and was at some later date inscribed with his life story. The moment when the metal rod made "Gage no longer Gage," the point when his selfhood was fundamentally changed, is marked by the simulacral presence of this missile-like object. To make a living as a human oddity, he carried the rod with him for the rest of his life, much like a saint who is depicted with the attribute of his martyrdom.

Among Jackson's thought objects, Gage's skull is a memento from an earlier era. Most of the artist's players are firmly grounded from the years following World War II up until the 1970s. Gage's rod has, in a sense, traveled through time to be physically rhymed with other projectiles that altered mankind's sense of itself, such as the bombs that fell on Japan in 1945 and Apollo 11's Command Module, the space craft that circled the moon when the Lunar Explorer Module allowed its occupants to take that one small step for man.

In order to make the massive expenditure of resources required to send men in space palatable to the public, the pilots had to be allowed to control *something* and the press responded by emphasizing the aspects of the mission with human, not mechanical protagonists. Any Hollywood scriptwriter could have predicted that, just as the lone astronaut exposed to the dangers of space haunts the cinematic-imaginary of space—conjured chillingly in Jackson's *Lonesome Soldier* (2008)—an astronaut is pinned high, specimen-like against the wall conjuring the sad end of many expendable characters in a thousand deep space thrillers.

To create *The Lower 48* (2006), Jackson traveled like a classic beatnik sojourner around all 48 contiguous states in a van over several months to photograph rock formations in which locals had found human likenesses, such as "Old Man in The Mountain" in New Hampshire. Such unlikely tourist sites are everywhere. The human instinct that makes almost every cul-

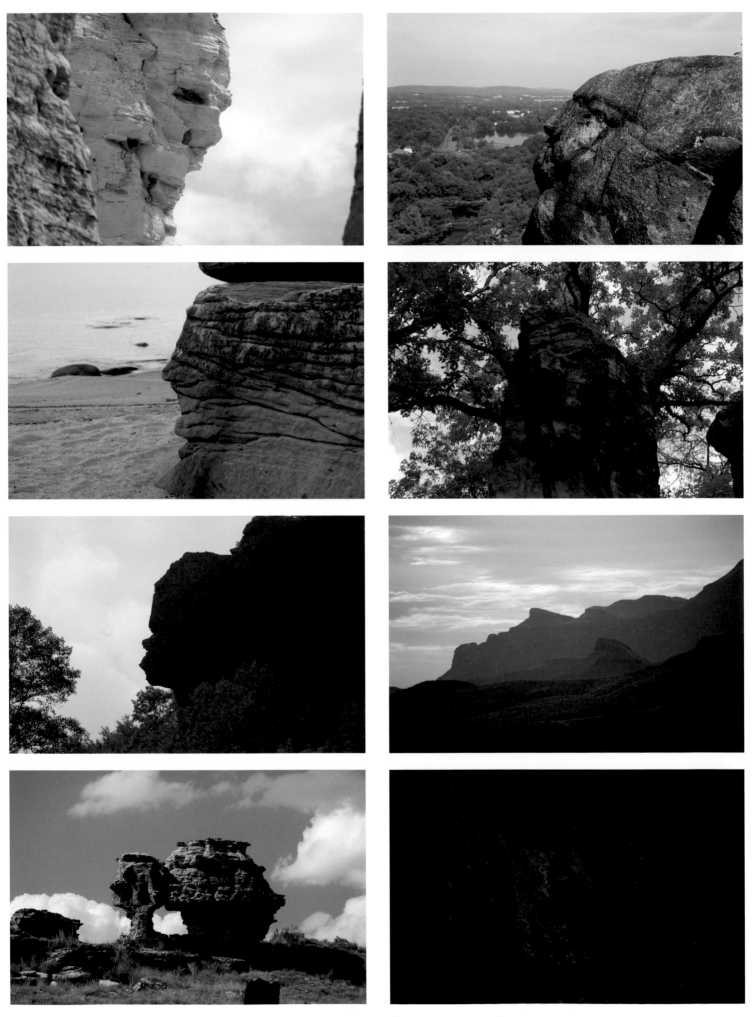

Selection from *The Lower 48*, 2006, Forty-eight photographs, installed in a grid
13 ½ x 20 inches, each sheet; 15 3/8 x 21 7/8 inches, each frame

Clockwise from top left: Kansas, Connecticut, Minnesota, Texas, Missouri,
Oklahoma, Virginia, Michigan,

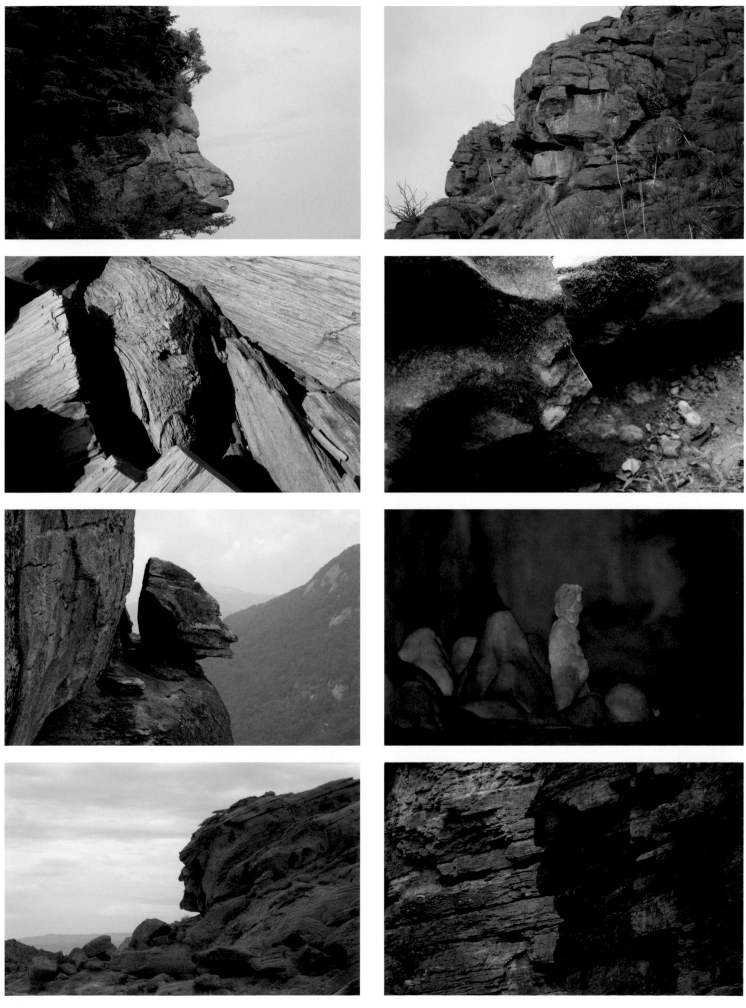

Clockwise from top left: South Carolina, New Mexico, Mississippi, Florida, New York, Nevada, North Carolina, Maine

Tensegrity Biotron, 2009
Two-way mirror, mirror, stainless steel, plastic cast bones,
neon light
55 ½ x 52 ¼ x 52 ¼ inches

ture see a face in the random patterns of the moon's craters belies mankind's love of finding its own presence mirrored in nature.

In Jackson's work the line between the built world and the body is fluid and forever shifting. In a device he has used throughout his career, his bones—their likeness discovered via X-ray and made in replica form—are made to function as design and/or architecture.

Tensegrity Biotron (2009) is a sculpture in the form of a Kenneth Snelson *Tensegrity* sculpture. The term "tensegrity" is short for "tensional integrity" and such forms, whether as sculptures or as design, appear today as iconic of the moment when high modernism slipped into the postwar vernacular of design. The form is remade in the simulated human bones. Jackson's making them organic and eccentric instead of using the sleek, uniform, and shiny elements employed by Snelson, and by his teacher Buckminster Fuller in his domes, points out the reality that its users always remade modernism in ways that were far from the designer's intentions.

In another dialogue with the history of sculpture, Jackson looks at the dialogue of post-minimalism. The sheer weight of Richard Serra's and Michael Heizer's sculptures taught the public to perceive many invisible qualities as intrinsic to the meaning of such works. Walking under a leaning mass of steel gives one a sense of its myriad potentialities: What would happen if it were to somehow fall or the floor were to give way? When the mind lingers on such harrowing thoughts, the weight of the works and the amount of potential force they contain is as readily perceivable as the gravity that fixes us to the earth. Later, Chris Burden, in works like *Samson* (1985) and the *Big Wheel* (1979), made those potentials literally move, both slower (a beam incrementally pushing into a supporting beam) and quicker (a giant, motorcycle-driven flywheel). Jackson, while specifically eschewing an aesthetic of danger *per se* is nonetheless fascinated by speed and how it might be locked in static forms.

Jackson commissioned the father of drag racing, "Big Daddy" Don Garlits, to build a display version of his Chrysler Hemi drag racing motor from *Swamp Rat VI*. Garlits's motor, which he built out of previously raced parts, had the potential to propel a body down a straight track at inhuman speeds. In this exhibition, it sits inert on an artist-designed motor-stand and has been titled as a classical sculpture, *Heart of Prometheus* (2009). Its mass only hints at what it could do were it fired up. Prometheus stole fire from the gods and he is often used as an image of the scientist who produces knowledge yet takes the blame for mankind's misuse of that knowledge:

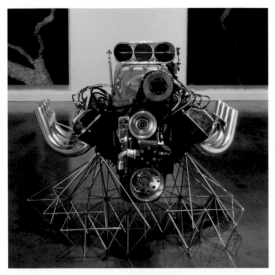

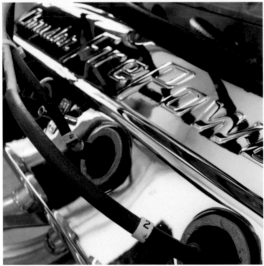

TOP
Heart of Prometheus, 2009
1957 Chrysler Hemi Display Engine built by "Big Daddy" Don Garlits (Nitro/Fuel Supercharged-2500 HP-354 CID-3 15/16" Bore-3 5/8"Stroke, as run in Don Garlits's *Swamp Rat VI-B*), steel, gold plating, brass placard
44 ½ x 48 x 34 inches

BOTTOM
Heart of Prometheus, 2009 (Detail)

In enduring myth, Prometheus was severely punished for giving humankind "every art and science"—the power to defy the forces of Nature. This concern about forbidden knowledge survives today…This public anxiety persists despite general satisfaction over the economic and life-extending benefits of scientific progress.

Scientific expertise offers a unique insight, and therefore responsibility, with regard to the human impact of new knowledge. Most scientists, however, are uncomfortable dealing with political machinery, and many lack the policy skills needed to relate their scientific expertise to social action. Since Hiroshima, scientists have often been pitted against that machinery, and have protested about being blamed for uses of science they were not permitted to control.[8]

The heart in the title refers both to the punishments that Prometheus received, (his heart—in some versions his liver—was pecked out daily by an eagle but grew anew to be devoured again) but more so to the spirit that compels man to pursue knowledge and experiences.

It is important to Jackson that the keys to speed were previously in the hands of government and industry, and Garlits was a normal citizen who used his ingenuity to steal fire from the powers that controlled it. Garlits was not a scientist, but he took the quotidian technology made by Chrysler, the Hemi motor, and repurposed it to produce extreme speeds. By retooling the technology and mixing more nitro in with the fuel, he was able to set land-speed records. He also suffered numerous injuries in his attempts to achieve his goals, losing half of his foot and being engulfed in flames behind a burning engine, but he continued to innovate in both driving techniques and engine design. His suffering for not accepting limits was Promethean—repeated, brutal, and yet endurable, given the prize. Jackson is also very interested in the fact that in drag racing today human limits have been reached. Higher speeds would not be manipulable by normal human physiology unaided by new mechanisms. New records have also hit the limit of being nearly immeasurable, a thousandth of a second being a normal increment today.

Jackson is the type of artist whose life and work have no discernable separation to an outside observer. While preparing for the show, Jackson learned to drag race at Frank Hawley's Drag Racing School in Gainesville, Florida. He earned his license from the NHRA (National Hot Rod Association) to drive in the Super-comp dragster division. He described his teacher as being more a Zen Master than the macho coach he was expecting. One could consider the artist as drag racer as a

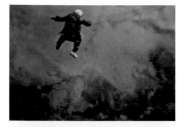

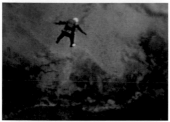

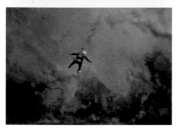

Kittinger, 2009
Mirrored box, steel, cedar stump,
projector
47 x 35 x 17 inches

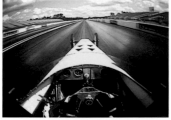

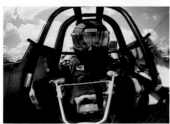

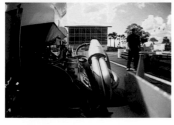

*Mapping the Studio (Fat Chance
Colonel John Stapp)*, 2009
Color DVD
12 minutes

performance piece, and he filmed aspects of his training to be presented in an art context. However, that suggests a campier attitude toward this American pastime than is the case with an artist of Jackson's mythopoetic sensibilities. He learned to race both out of an attraction to the renegade nature of the sport and as the only way he could know with his body such speed limits. He turned to drag racing after his request to film himself in the MIT Wright Brothers Wind Tunnel, nude and unprotected against a wall of fast-moving air, was denied. He envisioned his face mirroring the distorted visages of test pilots such as Colonel John Stapp in his deceleration rocket-sled tests of 1946. (Stapp's goal was to determine what amount of g-forces the body could withstand to systematically understand which plane crashes were survivable.)[9]

Another video loop shows test pilot Joseph William Kittinger II. Kittinger was part of the Aerospace Medical Research Laboratory's project *Excelsior*; in 1960, he performed a skydive from 102,800 feet, free falling for four minutes and achieving the highest speed a human body has survived. (The surreal video footage of Kittinger falling from low outer space is a cult favorite on YouTube.) It is impossible to see this footage of a man stepping out into the heavens and falling without making associations with fallen angels expelled from the heavens.

Another physical-metaphor of transformation is *Chariot II— I Like America and America Likes Me* (2008), first shown in an exhibition, *The Violet Hour,* at the Henry Art Gallery in Seattle near Jackson's family home in the Pacific Northwest. The work begins as a meditation on the unlikely fact that Jackson, with his family background, would be working as a fine artist and then it becomes a monument to the unlimited power of the human spirit to grow and to remake itself and the world. (The subtitle is derived from a work by German artist Joseph Beuys, whose work in homage to the power of positive transformation invited viewers to see his bodily presence as an artist in terms of pre-modern shamanistic practices.)

For *Chariot II*, Jackson rescued a crashed car frame from the front lawn of his cousin, racecar driver Skip Nichols, whose motorhead life was much more in keeping with Jackson's family traditions. The artist painstakingly restored and rebuilt the car as a material metaphor for transformation. One of the physical metaphors in the work is that the car appears to float on a spectrum of electronic lights arranged in the circular ROY G. BIV sequence.[10] They are not powered by the building's local power grid but always by some form of alternative energy.

For the MIT presentation Jackson has teamed with MIT's Energy Initiative. MITEI is dedicated to solving the world's

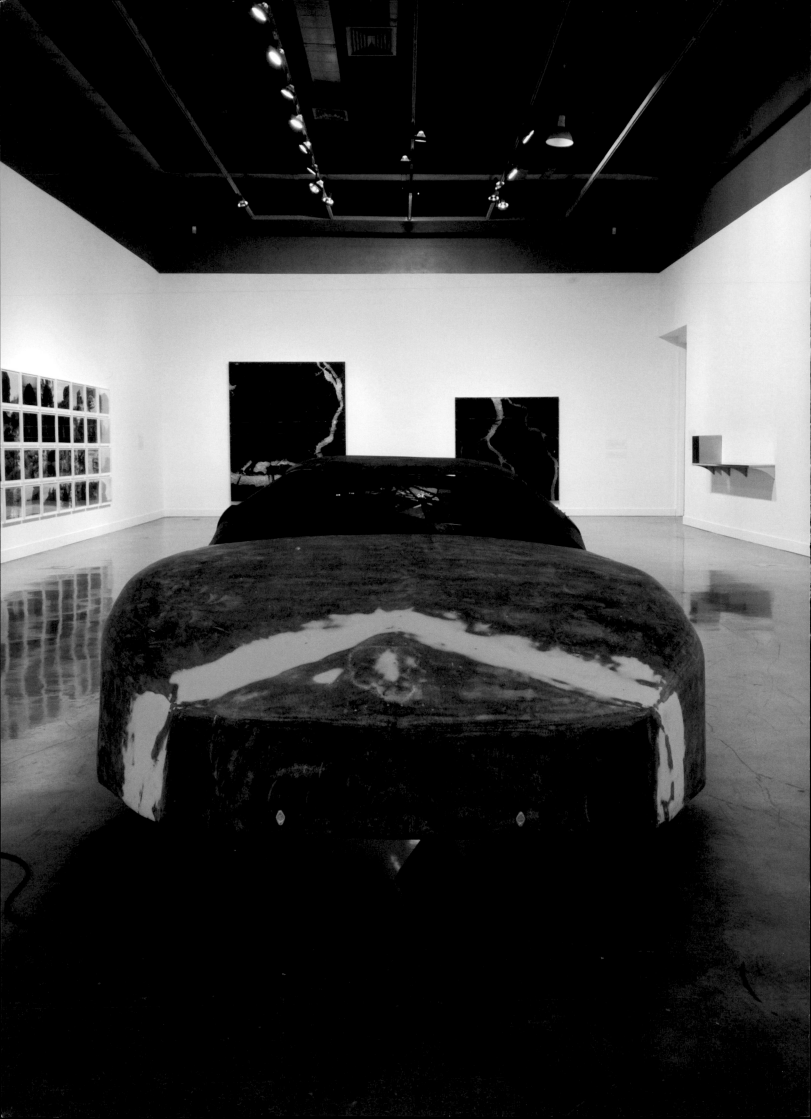

Chariot II—I Like America and America Likes Me, 2008
(Detail)

OPPOSITE
Chariot II—I Like America and America Likes Me, 2008
Car frame, steel, wool felt, leather, stained glass,
fluorescent light tubes, solar panel, fiberglass, and plastic
48 x 78 x 172 inches

FOLLOWING
Little Boy and Fat Man, 2009
Two channel B/W DVD
15 minutes

pressing concerns with the scarcity of reliable energy—its founding language from MIT president Susan Hockfield sounds very Bucky-Fulleresque:

> [It is] our institutional responsibility to address the challenges of energy and the environment. …Tackling the problems that energy and the environment present will require contributions from all our departments and schools…bringing scientists, engineers and social scientists together to envision the best energy policies for the future.[11]

MITEI's potential for the future is unlimited, and the group's website [http://web.mit.edu/mitei/index.html] contains often amazing discussions and talks that happen under its auspices. For this collaboration with Jackson, MITEI uses state of the art solar panels to collect enough sunlight to light the piece. The power cord between the solar collectors and battery and the lights emerges through a window, allowing visitors to follow the course of the cord and imagine the panels above and remind them that solar energy is the basic source of all energy forms. Whenever the artist shows the piece in the future, it will include a discussion of the achievements and potential of MITEI.

While many artists in the last decade have used the sculpted forms and cultural associations of car bodies (Richard Prince, Charles Ray), Jackson contextualizes the speed of Garlits's cars both within the larger attempt to go faster (the space program, parachute jumping, and speed trials), but also in the cultural sphere that values art-making as a form of useless expenditure that is more profound for being fiercely useless. The racers, astronauts, test pilots, and explorers that populate Jackson's works spend fuel, money, time, and effort; they risk life and limb drag racing, dropping from great heights, propelling themselves on sleds, or blasting into orbit as represented for no real reason and that seems both heroic and poetically useless in the Wildean sense—in other words, art:

> We can forgive a man for making a useful thing as long as he does not admire it. The only excuse for making a useless thing is that one admires it intensely. All art is quite useless.
> —Oscar Wilde, Preface to *The Picture Of Dorian Gray*[12]

The sense of wasted expenditure is intertwined in Jackson's world with experiments and innovations in energy and resumed manned space explorations that have very real-world consequences—a seeming contradiction. In coming to terms in the early part of the twenty-first century with the legacy of the twentieth century's triumphs and horrors, it is helpful to turn from practicalities to myths to allow us to distance ourselves enough to comprehend what has occurred, consider the implications and act responsibly for the future.

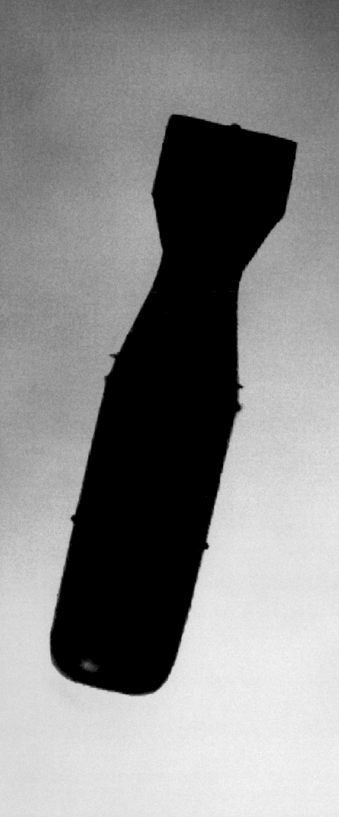

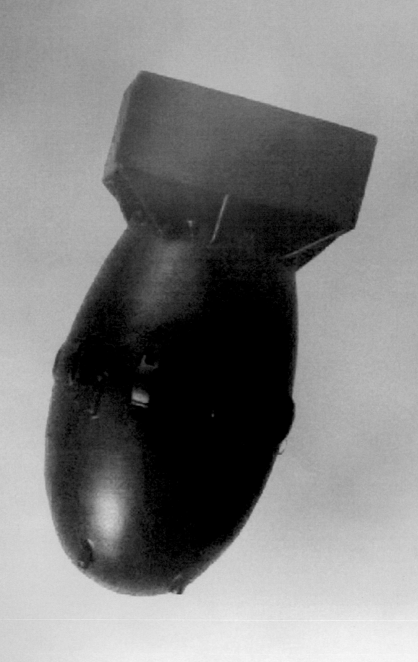

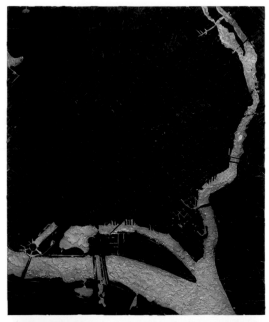

The twentieth century can be characterized and defined by the twin poles of dread of the dark side of the human mind—from Freud to Fascism—with a larger faith in progress that was tested when the first bomb was detonated at the Trinity Test site in Alamogordo, New Mexico, on July 16, 1945 and perhaps ended forever when they were dropped on the cities of Hiroshima and Nagasaki in August of that year.

Jackson filmed models of Little Boy and Fat Man in MIT's historic Wright Brothers wind tunnel. They appear as though they are falling forever, never hitting anything and never detonating. Thus, Jackson rewrites a story of apocalypse by adding a myth of delay or sleeping Hindu deities. The troubled gentleman-scientist who delivered to man the key to the power of global self-destruction, J. Robert Oppenheimer, emerged in a period in which scientists were expected to be well-read and cultured to better handle the complex ethical issues raised by science's new abilities. He famously quoted the *Bhagavad Gita* after the first nuclear test, saying "Now I am become death, the destroyer of worlds."[13] Oppenheimer's period, in which the contributions of poets, artists, and spiritual thinkers were widely valued in the sciences, and in the White House, was also the period in which the arts at MIT were introduced as a crucial part of any scientific education.

Jackson shows us in this video the nuclear age as a dream of pernicious gods that might have been forever delayed. Little Boy and Fat Man remain recognizable silhouettes. Their differences in design are also emblematic of the beginning of the race to design bombs for bigger explosions. The scientists who chose to continue developing more lethal bombs defended their actions via the scientists' dictum that if something is knowable it must be known.[14] This scientific competition led to the H-bombs, devices that could have destroyed the world. If the race between these two forever-falling bombs had been forever delayed, the soul-killing effects of the bombs would also have never occurred.

Jackson reengages the effects of the atomic bombs again in two paintings made from burnt wood and melted lead, both titled *August 6th, 1945* (2009)—the day the first bomb was used to end 140,000 lives. In fact, many will confuse the two images as the aerial views of the cities are similar. The images show two cities on rivers, but one is Hiroshima and one is Washington, DC. In Jackson's universe, the immolation destroys both those whose bodies were destroyed and those who chose to drop a device and thereby create a palpable fear of an impending apocalypse in the global imagination forever after. Aerial views are per se understood as God's perspective usurped by mortals; the mundanities that matter so much in daily life on the surface of the earth are made trivial and expendable. Those who would drop bombs and thereby end lives must adopt the same view in order to live

Paradise Now, 2006–2007
Color DVD
15 minutes, 7 seconds

with themselves. These paintings mark another example of a new human possibility made feasible via the power of flight, photography, and remote sensing that allow the hubris for which Gods in legends (and horror films) punish mortals.

Even in the face of horrors, Jackson proudly promotes redemptive strategies and demonstrates a resurgent belief that such a worldview pushed forward by artists might actually save us today especially in the redemptive power of the feminine spirit. In *Paradise Now* (2006-2007), a group of young female ghosts gather at Mies van der Rohe's modernist masterpiece, the Farnsworth House, to wonder why masculinist modernism did not save the world. Earlier in his career the artist dressed up as Eleanor Roosevelt in tribute to her role as author of the *Universal Declaration of Human Rights* in 1948—the healing spirit being in lock step with the reckless drive toward progress that is masculinist modernism.

This exhibition is subtitled *The Immeasurable Distance*, a phrase that is often used to describe the great dichotomies of life and the sense that the distance is too great to be measured. That does appear to be true, for such is the distance between life and death, freedom and bondage, between God and man, between lovers, between the moment of birth and the moment of death.

> The thought of the immeasurable distance a man travels--from the whipping top to this bed, on which he lay clasping a brandy. And to God it was only a moment. The child's snigger and the first mortal sin lay together more closely than two blinks of an eye.
> —Graham Greene in *The Power and the Glory*[15]

But it can also be too small, or non-existent. Some differences cannot be looked at or they will disappear, others will appear to swell to the size of a planet. The lessons of the twentieth century that fill Matthew Day Jackson's work, heart, and mind are not that progress, knowledge, or mankind itself are intrinsically good or evil. Rather that the only possible road forward is muddling through these immeasurable distances, these unknowable realities, constructing myths and stories that make events like Hiroshima or the moon landing comprehensible. Jackson has assumed a very ancient function for artists—that of representing reality through symbols—to make it known and to help steer toward a future still to be made real.

1 *The Future of Human Spaceflight-White Paper*, December 15, 2008, http://web.mit.edu/mitsps/index.html consulted March 30, 2009.

2 Ibid., 8.

3 See R. Buckminster Fuller, *Operating Manual for Spaceship Earth-Facsimile Edition* (Princeton NJ: Princeton Architectural Press, 2000).

4 All of the software for the Lunar Excursion Modules (LMs or LEMS) are called Luminary and the codes for the space capsules that circled the moon are Colossus, but the choice implies an understanding that these codes were the building blocks of future myths.

5 R. Buckminster Fuller, *Starting with The Universe*, June 26–September 21, 2008, an exhibition at Whitney Museum of American Art, New York, NY.

6 Malcolm Macmillan, *An Odd Kind of Fame: Stories of Phineas Gage* (Cambridge, Mass: MIT Press, 2000), 89–119.

7 See Antonio R. Damasio, *Descartes' Error: Emotion, Reason and the Human Brain* (New York: Penguin Books, 2005). Damsasio uses Gage's inability to make good decisions after the brain damage as support for the idea that properly functioning emotions are crucial for higher level cerebral functioning. See also Jesse Glass, *The Passion of Phineas Gage & Selected Poems* (Sheffield, U.K.: West House Books, 2006).

8 Joshua Lederberg, "Prometheus' Fire: Sharing the Responsibility," *The Scientist*, 21 January 1991, 5. Available online at http://www.the-scientist.com/article/display/10544/ consulted March 20, 2009.

9 http://www.ejectionsite.com/stapp.htm consulted March 19, 2009.

10 Roy G. Biv is a mnemonic device to allow neophytes to color theory to remember the spectrum as a proper name-an acronym of Red, Orange, Yellow, Green, Blue, Indigo and Violet. Such standard myth-making activities such as seeing figures in the dots of light in the night sky and naming them as constellations also have their origins as mnemonic devices.

11 http://web.mit.edu/mitei/about/ consulted April 13, 2009.

12 Oscar Wilde, *The Picture of Dorian Gray* (New York: Courier Dover Publications, 1993), vii-viii.

13 David Cassidy, *J. Robert Oppenheimer: And the American Century* (New York: Pi Press, 2004), 227.

14 See, for example, the interview with Edward Teller in the film *Trinity and Beyond: The Atom Bomb Movie*, (1995).

15 Graham Greene, *The Power and the Glory* (New York: Penguin Classics, 1990), 67.

CSDL-HC
APOLLO PROGRAM
Computer Programs

RAD LAB

DAVID HALBERSTAM

THINKING MACHINES Pratt

LUMINARY AND COLOSSUS

Deborah Douglas

We used to keep "the box" on the top shelf in the museum's reference and storage area. Weighing nearly 40 pounds, it was difficult to get it down, but I was fortunate that our visiting researcher that day was a tall man. We were both eager to see if the box contained what we had been searching for that afternoon amidst the records of the MIT Instrumentation Laboratory. We opened the old cardboard box top and there they were: two neatly stacked computer printouts, each more than 1,700 pages of continuous fanfold computer paper manufactured by Royal Business Forms, Incorporated: one labeled "Luminary" and the other "Colossus." If your name was Armstrong, Aldrin, or Collins and you were planning to go to the moon in 1969, these printouts would be your *Michelins* and MapQuests®.

Luminary and Colossus are the names of the two computer programs that guided the Lunar Excursion Module (Luminary) and the Command Module (Colossus) on their famous mission in July 1969 during which human beings first set foot on the moon. Thumbing through the pages reveals much to specialists in computer programming. The development of computer software for the Apollo program was a milestone in the history of software engineering. No one had ever managed such a large, real-time software project before; the lessons learned by NASA then are still in use today. Space missions were special because new software had to be written for each flight. Each program is a bit like a diary rather than a generic formula or recipe. By looking closely at the lines of code, you can uncover many of the technical assumptions that guided each and every mission. Want to know what Neil Armstrong and Buzz Aldrin were feeling as they landed the *Eagle?* Every shake and shimmy, all the intimate details of the human-machine interface, are in that code.

These programs are more than technical descriptions of what happened when. They were not soul-less exercises. Real people—researchers from the MIT Instrumentation Laboratory (now Draper Laboratory)—argued, struggled, and sweated every single line of code. These teams left the fingerprints of their cultural imagination and political sensitivities all over these programs. It is not a coincidence that the "master ignition routine" is called "Burn, Baby, Burn;" nor are the lines from Shakespeare that crop up in random places. And who could not miss the sexual innuendos in the two ground tracking programs named: "ComeKiss" and "Kissing"? This phenomenon of hiding secret treasures and tricks inside a program is hardly unique to Apollo software but rarely do ordinary people have the opportunity to see them on display as they are here.

The experience of reading through the programs line by line is similar to that of the meditative state associated with the creation of *karensansui*, or *zen* gardens. Whether the lines of code are filled with meaning or are simply bewildering sequences of letters and numbers, the observer cannot but be overwhelmed by the sublime sensations evoked by spaceflight. Like all great works of art, *Luminary* and *Colossus* are also works of astonishing human creativity for they are the codes that allowed human beings to defy gravity and explore the universe. *Ad inexplorata!*

OPPOSITE AND FOLLOWING
Luminary 1A, July 14, 1969, Apollo Guidance Computer program for use in the Lunar Excursion Module during the manned lunar landing mission, paper computer printout.

Colossus 2A, April 1, 1969, Apollo Guidance Computer program for use in the Command Module, paper computer printout.

Details on pages 36–39 from *Luminary 1A*

From the Charles Stark Draper Historical Collection housed at the MIT Museum, Cambridge, Massachusetts. Reproduced with permission from Draper Laboratory and the National Aeronautics and Space Administration.

UNAR LANDING GUIDANCE EQUATIONS

```
****************************************************************
```
UILDENSTERN: AUTO-MODES MONITOR (R13)
```
****************************************************************
```

EF 1 COUNT* $$/R13

 HERE IS THE PHILOSOPHY OF GUILDENSTERN: ON EVERY APPEARANCE OR
ISCRETE TO SELECT P67 OR P66 RESPECTIVELY: ON EVERY APPEARANCE OF
NLESS THE CURRENT PROGRAM IS P67 IN WHICH CASE THERE IS NO CHANGE.

				31.2467	0 0006 1	GUILDEN	EXTEND	
EF	5	LAST	748	31.2470	00 030 1	STERN	READ	CHAN30
EF	34	LAST	751	31.2471	7 4747 0		MASK	BITS
EF	231	LAST	763	31.2472	10 000 0		CCS	A
EF	1			31.2473	1 2551 0		TCF	STARTP67
EF	3	LAST	738	31.2474	0 5321 1	P67NOW?	TC	CHECKMM
				31.2475	00103 0		DEC	67
REF	1			31.2476	1 2557 0		TCF	STABL?
EF	2	LAST	794	31.2477	0 3740 1	STARTP66	TC	FASTCHNG
REF	2	LAST	373	31.2500	0 5311 1		TC	NEWMODEX
				31.2501	00102 1	DEC66	DEC	66
				31.2502	0 0006 1		EXTEND	
REF	6	LAST	315	31.2503	3 1474 1		DCA	HOOTDISP
REF	1			31.2504	53'645 0		DXCH	VOGVERT
REF	125	LAST	791	31.2505	0 6037 0	STRTP66A	TC	INTPRET
				31.2506	41535 1		SLOAD	PUSH
REF	1			31.2507	01457 0			PBIASZ
				31.2510	41535 1		SLOAD	PUSH
REF	1			31.2511	01455 1			PBIASY
				31.2512	55535 1		SLOAD	VDEF
REF	2	LAST	109	31.2513	01453 1			PBIASX
				31.2514	43161 0		VXSC	SET
REF	1			31.2515	25537 1			BIASFACT
REF	1			31.2516	00463 0			HODFLAG
REF	1			31.2517	26631 1		STOVL	VBIAS
REF	2	LAST	105	31.2520	01255 1			TEMX
				31.2521	77676 0		VCOMP	
REF	2	LAST	151	31.2522	27764 1		STOVL	OLDPIPAX
REF	13	LAST	786	31.2523	06522 1			ZEROVECS
REF	2	LAST	151	31.2524	17767 1		STODL	DELVROD
REF	2	LAST	122	31.2525	02540 1			RODSCALE
EF	2	LAST	151	31.2526	17757 1		STODL	RODSCAL1
REF	14	LAST	795	31.2527	01235 1			PIPTIME
REF	2	LAST	151	31.2530	03760 0		STORE	LASTTPIP
				31.2531	77776 1		EXIT	
REF	145	LAST	796	31.2532	3 4755 1		CAF	ZERO
EF	5	LAST	796	31.2533	55'620 0		TS	FCOLD
REF	5	LAST	796	31.2534	55'610 0		TS	FWEIGHT
REF	6	LAST	800	31.2535	55'611 1		TS	FWEIGHT +1
REF	1			31.2536	55'647 1	VRTSTART	TS	WCHVERT

```
NKCALL
JLEM

SCHNG           PREVENT RECALLING R60
024

6               IS THE LR ANTENNA IN POSITION 1 YET

N33

SPOT4           BRANCH IF ANTENNA ALREADY IN POSITION 1

E500            ASTRONAUT: PLEASE CRANK THE
NKCALL                          SILLY THING AROUND
PERF1
OPOOH           TERMINATE
SPOT3           PROCEED     SEE IF HE'S LYING

NKCALL          ENTER       INITIALIZE LANDING RADAR
POS1

TJUMP           OFF TO SEE THE WIZARD...
NDABY
```

```
D IGNALG

TABLE

                OCT 25:   INDEX FOR CLOKTASK

500

79.7 B-24
```

```
66440               GUIDDURN    +0.644003141 - 2

B-28            CRITERION FOR IGNALG CONVERGENCE
```

BURN. BABY. BURN -- MASTER IGNITION ROUTINE

REF	1			36,2273	3 3761 1	TIG-30A	CAF	V16N85B
REF	193	LAST	735	36,2274	0 4616 1		TC	BANKCALL
REF	1			36,2275	20465 1		CADR	REGODSP

**

REF	1			36,2276	3 3144 0	TIG-30	CAF	S24.9SEC
REF	11	LAST	735	36,2277	0 5173 1		TC	TWIDDLE
REF	3	LAST	241	36,2300	02352 1		ADRES	TIG-5
REF	3	LAST	735	36,2301	4 4762 1		CS	CNTDNDEX
REF	7	LAST	735	36,2302	55*163 0		TS	DISPDEX
REF	8	LAST	735	36,2303	51*455 1		INDEX	WHICH
				36,2304	3 0006 1		CAF	6
				36,2305	0 0006 1		EXTEND	
REF	5	LAST	733	36,2306	6 2325 1		BZMF	ULLGNOT
REF	8	LAST	734	36,2307	55*477 0		TS	SAVET-30
REF	12	LAST	736	36,2310	0 5173 1		TC	TWIDDLE
REF	2	LAST	239	36,2311	02346 1		ADRES	ULLGTASK
REF	23	LAST	724	36,2312	3 6245 1		CA	THREE
REF	97	LAST	716	36,2313	54 001 1		TS	L
REF	24	LAST	736	36,2314	4 6245 0		CS	THREE
REF	3	LAST	216	36,2315	52 753 1		DXCH	-PHASE1
REF	5	LAST	367	36,2316	4 0025 1		CS	TIME1
REF	1			36,2317	55*053 1		TS	TBASE1
REF	9	LAST	736	36,2320	51*455 1		INDEX	WHICH
				36,2321	1 0001 1		TCF	1
REF	11	LAST	295	36,2322	4 0106 1	WANTAPS	CS	FLGWRD1O
REF	7	LAST	295	36,2323	7 4737 1		MASK	APSFLBIT
REF	12	LAST	736	36,2324	26 106 1		ADS	FLGWRD1O
				36,2325	0 0006 1	ULLGNOT	EXTEND	
REF	10	LAST	736	36,2326	5 1455 1		INDEX	WHICH
				36,2327	3 0010 0		DCA	7
REF	3	LAST	105	36,2330	53*253 0		DXCH	AVEGEXIT
REF	38	LAST	713	36,2331	3 4752 0		CAF	TWO
REF	98	LAST	736	36,2332	54 001 1		TS	L
REF	39	LAST	736	36,2333	4 4752 1		CS	TWO
REF	3	LAST	224	36,2334	52 761 0		DXCH	-PHASE4
REF	6	LAST	736	36,2335	4 0025 1		CS	TIME1
REF	2	LAST	232	36,2336	55*061 0		TS	TBASE4

```
*********************
TION
*********************

    31
OC F2DPS+31

T* $$/P6567

    PHASCHNG
    04024

NT
    BANKCALL              ZERO ATTITUDE ERROR
    ZATTEROR

    BANKCALL             SET 5 DEGREE DEADBAND
    SETMAXDB

    INTPRET              TO INTERPRETIVE AS TIME IS NOT CRITICAL
    CLEAR
    SURFFLAG
    LETABORT
    VLOAD
    APSFLAG
    RN
L   ALPHAV
    PIPTIME
    CALL
    LUNAFLAG
    LAT-LONG
D   VLOAD               COMPUTE RLS AND STORE IT AWAY
    0
    RN
    PDDL
    PIPTIME
    CALL
    R-TO-RP
L   RLS

    V06N43*             ASTRONAUT! NOW LOOK WHERE YOU ENDED UP
    BANKCALL
    GOFLASH
    GOTOPOOH            TERMINATE
    +2                  PROCEED
    -5                  RECYCLE

    INTPRET
```

DIGITAL APOLLO (FROM *SPACECRAFT AND SYMBOLISM*)

David Mindell

As different as they were, Michael Collins shared one characteristic with Roscoe Turner: both were on display. Turner flew in an age when aviation's commercial potential had yet to be realized, when the airplane remained a dazzling curiosity and most professional pilots earned a livelihood through entertainment. By Collins's day a pilot could make a living with more prosaic tasks like flying airliners; however, the astronauts, like Turner, worked with a technology of unclear civilian utility but whose imagery captivated the attention of the press, the public, and the state.

Put a human being inside a rocket, add the resonance of a journey into the blackness of space with all its allusions to the heavens and the long history of human fascination with the stars, and one has a technology that linked humankind's most earthly, practical endeavors (fuels, oxidizers, pipes, breathing, eating, shitting) to its most lofty ambitions.

None of the symbolic power of spaceflight was lost on the visionaries who promoted the space program, the politicians who supported it, the press who reported it, or the public who consumed the news about it. They very consciously built symbols as well as spacecraft.

In creating that symbolism, the Kennedy administration drew on American imagery of exploration, individualism, and geographical conquest to sell Apollo to the press and to Congress. Kennedy seized on the most powerful mythology in American history, the frontier narrative, and reopened it by aiming for the moon. Within this framing, the endeavor had all the elements of a classic frontier adventure: an unknown, but conquerable geography full of lurking dangers, even villainous antagonists—the competing Soviets.

Most important, the frontier narrative called upon heroic pioneers. The press may have been biased against large government projects (delighting in exposing waste and fraud), but they were heavily biased in favor of individual, human tales. Human presence made spaceflight into a story. For the American public, that story involved people who embodied American virtues, from humility and self-control to self-reliance and creativity, "part Davy Crockett and part Buck Rogers."[19] And for that story to be credible, the astronauts had to be in control. Frontiersmen could not be passengers.

Imagery of active pilots pervaded Apollo, but coexisted with another, subtler trend. The moon project resonated within a culture deeply concerned with the social implications of technology. It was conceived in the wake of Russia's Sputnik success and in the early Kennedy years when large-scale science and technical and managerial projects seemed to promise solutions to political prob-lems. But Apollo unfolded in the era of Vietnam, 1960s counterculture, and increasing questioning of the social benefits of large technological systems. Commentators worried about the phenomenon of "deskilling" as computerized machine tools transformed work on the factory floor.[20] In his speeches and writings, for example, Martin Luther King frequently mentioned automation as a cause of the social displacements he was seeking to redress. Even NASA director James Webb suggested that the jobs generated by the Apollo program would help mollify unemployment created by automation.

The Apollo years spanned the release of Stanley Kubrick's *Dr. Strangelove* (1964), about an automated Soviet machine that triggers the end of the world, and his *2001: A Space Odyssey* (1968), in which an intelligent computer murders American astronauts. Also during Apollo, Jacques Ellul's book *The Technological Society* (published in 1965 in English) challenged the increasing dominance of "technique" in human culture. In 1967 Lewis Mumford named the "megamachine" as the aggregate of technology, social organization, and management that suppressed individual human values. Philip K. Dick published *Do Androids Dream of Electric Sheep?* in 1968 (later made into the film *Blade Runner*), recasting traditional demarcations between humans and machines. Thomas Pynchon's *Gravity's Rainbow* (1973) took "the rocket" as its central literary figure, exploring the technical, psychological, and religious dimensions of a state that worshiped at the altar of technology, and the paranoia engendered by its invisible, clockwork plans.[21]

NASA and its astronauts faced such tensions in the daily engineering of their systems, questions with the potential to undermine the symbolic agenda of the program. Would the exigencies of rockets, supersonic flight, and split-second decisions, not to mention onboard computers, threaten the classical heroic qualities? What tasks were susceptible to human skill, and what was too fast, complex, or uncertain for a human to intervene? How were Apollo designers to engineer a system that had a place for a heroic operator? As Apollo's machines were designed, built, and operated they called the very nature of "heroism" into question. What did it mean to be in control?

19 Kauffman, *Selling Outer Space*, 36–37, 56–67.
20 Braverman, *Labor and Monopoly Capital*; Noble, *Forces of Production*; Bix, *Inventing Ourselves Out of Jobs?*
21 Hong, "Man and Machine in the 1960s"; Turner, *From Counterculture to Cyberculture*; Dick, *Do Androids Dream of Electric Sheep?*; Ellul, *The Technological Society*; Mumford, *The Myth of the Machine*; Pynchon, *Gravity's Rainbow*.

Vertigo, 2009
B/W DVD
59 minutes, 3 seconds

PRECEDING
Study Collection, 2009 (Detail)
cast bootprint

OPPOSITE
Pilgrimage, 2009
Three channel DVD
Variable timed loops

FOLLOWING
Photographs from *Mapping the
Studio (Fat Chance Colonel John
Stapp)*, 2009

FLAT MAPS: SIX NOTES ON MATTHEW DAY JACKSON'S *THE IMMEASURABLE DISTANCE*

Tom Morton

1

The pre-Socratic philosopher Zeno of Elia's *Paradox of the Arrow* states that for an object to be in motion, it must change the position that it occupies. In any single instant of time, an arrow in flight (say) must move to where it is, or where it is not. It cannot move to where it is, of course—it's already there—but neither, this being a single instant, can it move elsewhere. In a temporal snapshot, the projectile is motionless. Even in an infinite series of temporal snapshots, it covers no ground at all. According to Zeno's logic, the astronaut does not reach the moon, and the bomb does not fall. The drag racer does not cross the finish line, and the flying length of iron does not pierce flesh and bone. There is no progress, here. Time's arrow is still, always still.

2

The notion of an immeasurable distance is an oxymoron. *Merriam-Webster's Collegiate Dictionary* defines distance as "the degree or amount of separation between two points, lines, surfaces, or objects," which is to say as something that may be physically or (in the lack of sufficiently sophisticated tools) conceptually measured. It follows that a distance that cannot be measured is no distance at all. It is a single point, or line, or surface, or object, or the utter absence of these things. It is a monadic universe, or a void—a zero or a one.

3

On September 16th, 1949, 17 days after the USSR tested its first nuclear weapon, "Lightning's First Strike" in Semipalatinsk, Kazakhstan, the animated *Looney Tunes* characters Wile E. Coyote and Roadrunner made their U.S. TV debut. Created by Chuck Jones and Michael Maltese, this series of short cartoons would run into the 21st century, never wavering from its central narrative: the unsuccessful pursuit of a flightless bird along a desert highway by a hapless canine predator. Like many cartoons, they adhere to a strict set of rules, which we might enumerate thus:

i. The Roadrunner must always stay on the road, for no other reason than that he's a roadrunner.

ii. Wile E. Coyote will always and only chase the Roadrunner, despite the clear availability of other food sources in his environment. No outside factor compels his pursuit of the bird, and he could stop anytime, were it not for his own fanaticism.

iii. The Roadrunner is faster than Wile E. Coyote. (In the natural world the ostrich, the bird that most closely resembles the Roadrunner, can achieve a top speed of around 45mph, and a coyote roughly the same).

iv. To compensate for his comparative lack of speed, Wile E. Coyote makes use of technology, typically projectiles (catapults), explosives (dynamite), or a combination of the two (rockets). All such technology is obtained from the ACME Corporation, a fictitious mail-order company whose name stands in ironic counterpoint to the efficacy of its products. ACME devices invariably malfunction, leaving Wile E. Coyote squashed flat, burnt to a crisp, or at the bottom of a canyon.

v. The Roadrunner is able to take full advantage of "cartoon physics," passing through painted images, and gamboling across great chasms in the desert landscape. For Wile E. Coyote, however, real-life physics always eventually takes over, leading him to smack painfully into *trompe l'oeil* roads daubed on a rock-face, or to plunge into a crevasse when he realizes, hanging in mid-air, that he has overshot its edge. He recovers quickly from these episodes, although he never seems to learn from them. The chase is always resumed.

vi. No outside force can harm Wile E. Coyote, only his own ineptitude, or the failure of the ACME technology he employs.

vii. Wile E. Coyote never captures the Roadrunner. He is fated to perform, eternally, this sacrament of thwarted desire.

viii. The audience's sympathy always remains on Wile E. Coyote's side.

Chuck Jones has said that he based Wile E. Coyote on a description of a coyote in Mark Twain's semi-autobiographical travelogue *Roughing It* (1870–71), in which the creature is characterized as "a living, breathing allegory of Want. He is always hungry." Jones' creation, however, also shares several attributes (principally appetite, technical ingenuity, and a propensity for breaking taboos that never goes unpunished) to the figure of Coyote found in the myth cycles of many Native American groups, where he plays the dual role of trickster and culture hero. Wile E. Coyote also has a further analogue in the Classical Greek Prometheus, a mortal who stole fire from the immortal Gods, and was penalized by Zeus by having his liver pecked out daily by a ravenous vulture—what are the contraptions of the ACME Corporation, after all, if not smoldering embers for the rocket age, backfiring spectacularly on those that would use them to doubtful ends? The Roadrunner's antagonist, however, runs afoul not only of technology, but of art, too. He is an animated creation who can never take full advantage of his animated ecosphere. While for his quarry a mountain is nothing but a pencil and ink fiction to scamper happily through, for him it is an obstacle to climb, or to collide painfully with. We might think of Wile E. Coyote as an artist, and the Roadrunner as that ineffable thing, art. Only in a single stop frame cell (a cartoon version, perhaps, of Zeno's temporal snapshot) do they occupy the same reality—one, indivisible world.

Photographs from *Mapping the Studio
(Fat Chance Colonel John Stapp)*, 2009

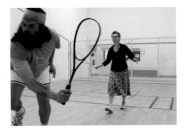

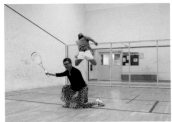

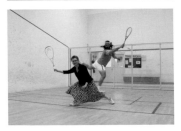

Photographs from *Playing Squash,
Los Alamos, New Mexico,* April 2009

4

On September 13, 1848, a trackside explosion propelled a tamping iron through the eye-socket, frontal lobes and skull of the American railway worker Phineas Gage. Remarkably, Gage survived the accident, although the damage to his brain caused a marked change in his previously peaceable personality, as the physician Dr. John Martyn Harlow described: "The equilibrium or balance, so to speak, between his intellectual faculties and animal propensities, seems to have been destroyed. He is fitful, irreverent, indulging at times in the grossest profanity (which was not previously his custom), manifesting but little deference for his fellows, impatient of restraint or advice when it conflicts with his desires, at times pertinaciously obstinate, yet capricious and vacillating [...] A child in his intellectual capacity and manifestations, he has the animal passions of a strong man [...] In this regard his mind was radically changed, so decidedly that his friends and acquaintances said he was 'no longer Gage.'" Unable to work on the railways, the unfortunate Gage found employment at P.T. Barnum's American Museum in New York City, where curious visitors paid to see both him and the instrument of his transformation, now inscribed with the details of the fateful incident, which he reportedly carried with him at all times. In physically enduring what would usually be a fatal injury, Gage seems perhaps closer to a cartoon character than to a flesh and blood human being, and it is hard not to imagine him as a real-life Wile E. Coyote—a figure "impatient of restraint or advice when it conflicts with his desires" who saw more than his share of railroad accidents in his hopeless scramble after the speeding bird. (We might also think of Gage as an ancestor of the Polish-Romanian artist André Cadere, who famously placed his "Barres de bois," or painted round wooden bars, uninvited into other artists' shows. The tamping iron must have changed, momentarily at least, perceptions about every other object in the room's totemic potential, or threat.) Maybe Wile E. Coyote, like Gage, was once a still soul, before his coyote nature emerged following some terrible founding accident. Or maybe he, like the Roadrunner, has always just run.

5

In a 1962 letter to General Leslie Groves, J. Robert Oppenheimer, scientific director of The Manhattan Project, attempts to explain why he gave the first nuclear weapons test in Los Alamos in 1945 the codename "Trinity." There is a poem of John Donne [*Hymne to God, my God, in my Sickness*, 1630], written just before his death, which I know and love. From it a quotation: "As West and East / In all flat maps—and I am one—are one, / So death doth touch the Resurrection." "West," in Donne's symbolic schema, stands for death, and "East" for life, and it's *possible* to interpret Oppenheimer's musing of this line as an indication of the coming atomic bombing of the Japanese cities of Hiroshima and Nagasaki,

or even the brief disparity in nuclear capability between America and Russia, the enemy-in-waiting. Donne, though insists on the oneness of these disparate geographical points, just as he insists on the oneness of his mortal and immortal soul (the "flat map" recalls nothing if not Zeno's suspended arrow, or an animator's drawing), and in drawing on the poem for the name of the test, Oppenheimer seems to be searching, if not for a way to turn back time, then for at least a guarantee that it will be rebooted after nuclear armageddon descends. Only Gods and cartoons, though, are ensured resurrection, and as he watched the mushroom cloud go up in the New Mexico desert, he famously recited to himself a line from the Hindu Bhagavad-Gita, which he translated as: "I am become death, the destroyer of worlds." "Death," though, in this Sanskrit passage, may also be translated as "time," and perhaps it is this translation that is in the end more devastating. Oppenheimer's children (his Little Boy, his Fat Man, and their ugly, brutal descendents) have not yet succeeded in destroying the world, but they have destroyed a possible world—a world without a nuclear gun cocked permanently in its mouth. Time does not stand still. Time cannot be reversed. As the novelist Martin Amis has written in his essay on the arms race *Einstein's Monsters* (1987): "If things don't go wrong, and continue not going wrong for the next millennium of millennia, you get… What do you get? What are we getting?"

Perhaps Oppenheimer's hoped-for salvation could only occur on a planet such as Jorge Luis Borges' Tlön in his short story *Tlön, Uqubar, Orbis Tertius* (1940)—a place, detailed in an obscure encyclopedia, where nouns do not exist ("moon," here, is expressed adjectively as "round airy-light on dark," or "pale orange of the sky"), and reality is understood "not as a concurrence of objects in space, but as a heterogeneous series of independent acts." Tlön, however, is not just a fiction, but one that Borges, the narrator of the tale, reports has been dreamt up by a secret society so that it might replace the world in which we live. In his postscript, he tells us that "Already Tlön's (conjectural) 'primitive language' has filtered into our schools; already the teaching of Tlön's harmonious history (filled with moving episodes) has obliterated the history that governed my own childhood; already a fictitious past has supplanted in men's memories that other past, of which we now know nothing certain—not even that it is false." This postscript is dated 1947—two years after Oppenheimer became time, two years after he substituted one planet for another.

6

The Chinook tell of how Coyote and Eagle went to the Land of the Dead to bring back their wives. Arriving there, they found a meeting lodge lit only by the moon, which lay upon the floor. Every night an old woman would swallow the pale orb and the dead would appear in the lodge, and when she regurgitated it just before dawn they would file out of the door and fade into the forest. Recognizing their wives among the spirits, the two gods devised a plan. The next day, after the old woman had vomited up the moon and the dead had disappeared, Coyote built a huge wooden box and placed in it leaves of every kind of plant. Coyote and Eagle then killed the old woman, and Coyote put on her clothes. When the time came, Coyote swallowed the moon. The dead appeared, but Eagle had placed the box outside the exit. When Coyote vomited up the moon, the dead filed out and were trapped in the box. Coyote pleaded to be allowed to carry the box back to the Land of the Living, and Eagle gave it to him. But Coyote couldn't wait to see his wife and opened up the box. The spirits of the dead rose up like a cloud and disappeared to the West. So it is that people must die forever, not like the plants that die in winter, and are green again in spring.

FOLLOWING
Matthew Day Jackson and
Olivia Fermi
*Playing Squash, Los Alamos,
New Mexico,* April 2009
Color DVD
28 minutes

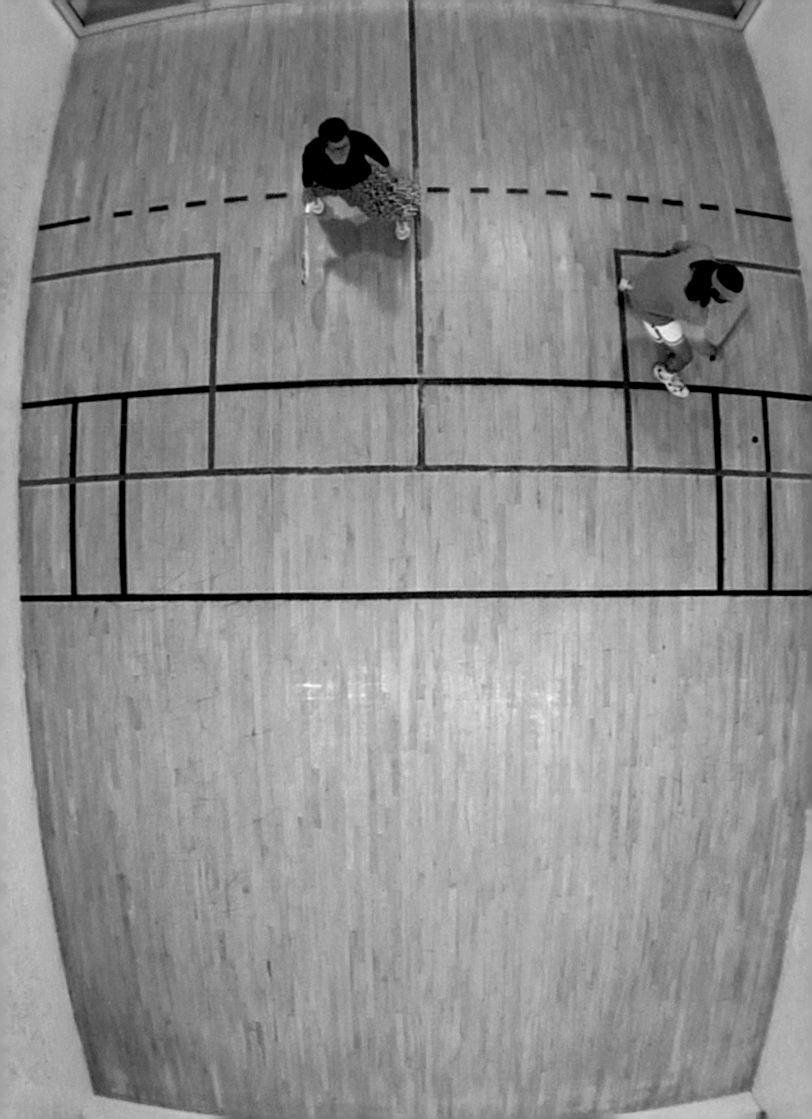

A PROJECT OF BIRD

APPROVED BY

FAI

Fédération Aéronatique
Internationale

bzzzzzzzzzzzzzzzz

"CRACKLE"

vvvvvvvvvvvvvvvv

WELL
HOO
DE
HOO
DE
HOO,
FOLKS.

THIS IS
WALT DANGERFIELD,
YOUR ORBITAL DJ,
MOVING INTO RANGE AGAIN.
DON'T TOUCH
THAT DIAL!
WE DON'T HAVE
MUCH TIME,
AND
WE WANT
TO MAKE
THE MOST
OF
IT.

YOU ALL KNOW MY STORY.
CLIMBED ATOP A ROCKET,
AIMING FOR MARS.
FIRST COLONISTS ON MARS AND
ALL THAT. THEN—WELL, YOU
REMEMBER. NEVER MADE IT TO
MARS, DID I? INSTEAD
HERE I AM UP HERE,
IN A GEOSYNCHRONOUS ORBIT
ABOUT, OH, 620 MILES
ABOVE YOU,
BRINGING YOU
ALL THE TUNES AND NEWS
YOU CAN USE!
ONCE A DAY,
ANYWAY.

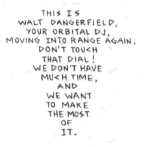

COMING OVER
THE WESTERN U.S.A. NOW.
LOTTA CLOUDS DOWN THERE,
LOOKS LIKE, BUT UNDERNEATH
THAT NOT TOO BAD A DAY.
OKLAHOMA,
CAN YOU HEAR ME?
A STATE
I KNOW WELL.
LOTTA HISTORY, LOTTA LORE.
DUST BOWL,
LAND RUSH,
TRAIL OF TEARS.
OKLAHOMA
OK!
SHOUT IT OUT
PROUD.

WESTERN OK
NOW,
THERE'S THE PANHANDLE.
TIME WAS THEY CALLED THIS
NO MAN'S LAND,
BACK THERE IN THE DAY.
ROCK,
DUST,
COMANCHE,
BUFFALO.
BUFFALO BONES.

FOLKS,
YOU EVER READ ABOUT THE
BIG HUNTS BACK THEN?
WIPED THOSE BUFFALO CLEAN
OUT. LEFT THE CARCASSES
TO ROT. LAY THICK AS 50 TO 100
WITHIN A COUPLE HUNDRED YARDS.
BONE COUNTRY, LIKE
SOMEBODY DROPPED A BOMB.
FIRST STRAGGLY COLONISTS HERE
MADE A POOR LIVING
COLLECTING THOSE BONES.
SOLD 'EM DOWN
IN KANSAS,
10 BUCKS A TON.
THERE'S AN OLD DITTY,
GOES
LIKE THIS:

PICKIN' UP BONES
 TO KEEP FROM STARVIN'
PICKIN' UP CHIPS
 TO KEEP FROM FREEZIN'
PICKIN' UP COURAGE
 TO KEEP FROM LEAVIN'
WAY OUT WEST IN NO MAN'S LAND

WAY OUT WEST IS RIGHT,
ALMOST IN NEW MEXICO TERRITORY.
THERE'S OL' BLACK MESA,
AND THERE'S THE CIMARRON.
IF YOU HAVEN'T SEEN 'EM,
CHECK OUT
THE PETROGLYPHS
IN THE CAVES SOMETIME.
THOUSANDS
OF YEARS
OLD,
WHO KNOWS
WHO MADE 'EM ?

THERE'S OL' ROUTE 325
HEADED WEST —
AND HERE IT IS,
OUR LAST STOP
BEFORE THE LINE —
CAN YOU
HEAR ME,
KENTON ?
KENTON, OKLAHOMA !
I
GOT YOU
IN MY
SIGHTS.

NOT MUCH
TO LOOK AT,
MAYBE,
BUT
WE KNOW
BETTER,
DON'T WE ?

KENTON'S
ONE OF THOSE WHAT YOU MIGHT
CALL SECRET SPOTS.
END OF THE LINE,
START OF SOMETHING ELSE.
LOT GOING ON,
LOTTA PEOPLE COMING THROUGH:
INJUNS, SCOFFLAWS,
OUTLAWS + SCUMBAGS ...
DETHRONED ROYALS,
FREELANCE MOYLS,
PLUS
PLENTY OF THEM
EMIGRE
ARTISTS
+
SCIENTISTS
TOO ...

YEP,
QUITE A BUNCH.
AND
WHERE DO THEY
ALL STOP ?
WHY,
THEY STOP
AT
THE MERC !

THE MERC.
GENERAL STORE
&
MUSEUM
OF
NATURAL HISTORY,
CHTHONIA,
&
HERMENAUTICS.

M.D. JACKSON,
PROP.

THE MERC,
THE MOST
ANOMALOUS
SPOT
IN
THE
WEST.

YOU KNOW THE STORY,
DON'T YOU?
IN 1898
OL' DREW BARNUM,
NEPHEW OF THE GREAT P.T.,
FOUNDED THE PLACE.
BEEN OPEN EVER SINCE,
SHOWING STUFF
AND
SELLING IT TOO.

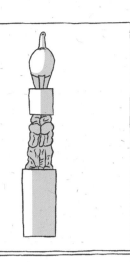

AND WHAT STUFF!
SINCE EVERYONE AND EVERYTHING
SOONER OR LATER
TAKES A TURN
IN NO MAN'S LAND,
THE MERC'S THE SPOT
WHERE A LOTTA
UNIQUE + INTERESTING
STUFF
COMES TO REST.

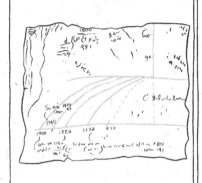

PILE UP
SO MUCH
INTERESTING STUFF
AND
PRETTY SOON...

WELL.
SUFFICE TO SAY
Y'ALL
SHOULD
STOP BY
AND
HAVE
SOME
PIE.

FOLKS,
I'VE GOT A LIST HERE OF WHAT'S
GOING ON AT THE MERC TODAY.
THANK YOU BELOW
FOR KEEPING ME APPRISED.
NOW, FIRST OF ALL, WE HAVE
TODAY'S LAUNCHES — I KNOW WE'LL
ALL BE TUNING IN FOR THOSE.

LET'S SEE,
DOWN IN NEW MEXICO
WE'VE GOT
CAPTAIN JOE KITTINGER
DUE TO GO UP
IN HIS BALLOON...

...WHILE UP IN IDAHO
WE'VE GOT THAT EVEL KNIEVEL
ABOUT TO TRY TO JUMP
THE SNAKE RIVER
IN THAT
MOTORCYCLE ROCKET
OF HIS...

WELL, MORE ON THAT ANON.
WE'VE ALSO GOT A BIG
SHOW TODAY, YOU KNOW THE ONE —
YEP, IT'S THE
NATURE THEATRE OF OKLAHOMA,
PROMISING A BLAST.
NOBODY'S GONNA WANNA MISS THAT!
GOT AN ANNOUNCEMENT
ABOUT IT, WE'LL READ IT A
LITTLE LATER ON.

WHAT ELSE?
LET'S SEE, OH YEAH — WE'VE GOT
LECTURES + WORKSHOPS,
AROUND THE CLOCK, THEY NEVER STOP,
WE'VE GOT —

– CAPTAIN AHAB, LATE OF THE
 PEQUOD, WITH A WORKSHOP ON
 SCRIMSHAW

– HERR DOKTOR PROFESSOR
 ALBERT EINSTEIN WITH A
 LECTURE ON ENERGY + MASS

– MR. PHINEAS GAGE, LATE OF
 THE VERMONT RAILROAD, SHOWING
 HOW HE SURVIVED A 3-FOOT
 8-INCH TAMPING ROD SHOT
 CLEAN THROUGH HIS HEAD

– PROFESSOR EDWARD TELLER
 WITH THE NUCLEAR ABCS

– WALTER BENJAMIN LECTURING
 ON ALLEGORY

– JOSEPH BEUYS, LATE OF THE
 LUFTWAFFE, WITH A WORKSHOP:
 "SCULPTURE AS AN EVOLUTIONARY
 PROCESS: EVERYONE AN ARTIST."
 SUGGESTED MATERIALS:
 COAL, BONES (BUFFALO
 PREFERRED), PLANE PARTS,
 FAT, GLUE, + TANG

– J. ROBERT OPPENHEIMER
 LECTURING ON THE
 BHAGAVAD-GITA

– MARCEL DUCHAMP ON AVIONICS

– AND TODAY'S MEETING OF THE
 KENTON ROCKET CLUB, WITH A
 GUEST LECTURE BY WERNHER
 VON BRAUN, LATE OF THE SS.

WELL NOW, THAT'S QUITE A LINEUP,
ISN'T IT? LET'S LISTEN IN
A BIT —

– A MEDICAL MIRACLE –
– THE WONDER OF THE AGE –
"HE HAS NO EQUAL"

MR.
PHINEAS
GAGE,
ESQ.

NOW EXHIBITING
EXCLUSIVELY AT
THE MERCANTILE,
KENTON, OKLAHOMA.

YEP, THIS IS THE VERY ROD
ITSELF. WE USED IT TO TAMP DOWN THE
CHARGE WHEN WE WAS BLASTIN' ROCK
TO LAY TRACK FOR THE RAILROAD. THIS
ONE HERE'S 3 FEET 8 INCHES
LONG AND 1 + 1/4 INCHES THICK.

WELL, THAT DAY – THIS WAS BACK
IN '48 – THE CHARGE WENT OFF BEFORE
IT WAS SUPPOSED TO. BLASTED THIS
ROD RIGHT THROUGH THE SIDE OF MY
FACE, BEHIND MY LEFT EYE, AND OUT
THE TOP OF MY HEAD.
KINDA LIKE THIS —

BLEW OUT BOTH
FRONTAL LOBES IN MY BRAIN,
THAT'S WHAT THEY SAY — BLEW 'EM
CLEAN OUT. I LIVED, THOUGH —
FOR ANOTHER 12 YEARS.

KINDA HARD TO MAKE A LIVING AFTER
THAT, THOUGH. FOR A WHILE THERE
P.T. BARNUM PUT ME IN HIS SHOW.
I DID A LITTLE NUMBER WITH THIS
ROD, PLUS SHOWED FOLKS THE HOLES
IN MY HEAD. MADE UP A LIMERICK TOO,
WENT LIKE THIS:

THERE ONCE WAS A FELLA NAMED PHINEAS,
HE WAS SOBER, CHURCHLY, + SERIOUS.
A ROD THROUGH THE BRAIN,
LAYIN' RAIL FOR THE TRAIN,
MADE HIM DRUNK, DROOLY, + DELIRIOUS.

DIDN'T KEEP, THOUGH. THE JOB,
I MEAN. I KINDA HAD TROUBLE WITH
THINGS AFTER THE, YOU KNOW, ACCIDENT—
COULDN'T KEEP TRACK OF THINGS,
IF YOU KNOW WHAT I MEAN. TIME WASN'T
RIGHT, KEPT GOIN' FUNNY ON ME. WAS
LIKE, I DUNNO, I'D COME
UNSTUCK IN TIME...

SPENT SOME TIME
DOWN IN CHILE, THEN CALIFORNIA,
WHERE I PASSED ON. LATER
I STARRED IN A MOVIE
WITH THAT EVEL KNIEVEL.

6.

SITZUNG
DES
KENTON
RAKETEKLUB.

GASTDOZENT:
WERNHER
VON BRAUN

VE CALL DELTA-V
THE THEORETICAL TOTAL CHANGE
IN VELOCITY THAT A ROCKET CAN
ACHIEVE VIZOUT ANY EXTERNAL
INTERFERENCE – THAT IS,
VIZOUT GRAVITY, AIR DRAG,
OR OTHER FORCES.

TO CALCULATE THE DELTA-V
THAT A ROCKET CAN PROVIDE, VE USE
THE FOLLOWING FACTORS:
M_0 IS THE INITIAL TOTAL MASS, INCLUDING
PROPELLANT IN KG
M_1 IS THE FINAL TOTAL MASS IN KG
V_e IS THE EFFECTIVE EXHAUST VELOCITY
Δ_v IS THE DELTA-V IN M/S

$$\Delta_v = V_e \ln$$

ARMED VIZ THESE,
WE CAN NOW CALCULATE THE
TSIOLKOVSKY ROCKET EQUATION:

$$\Delta_v = V_e \ln \frac{m_0}{m_1}$$

SO YOU SEE –
EMPLOYING THE T.R.E., IT BECOMES
POSSIBLE FOR US TO IMAGINE AN ALMOST
INFINITE DELTA-V – ROCKETS
ACHIEVING VELOCITIES
BOUNDED ONLY BY
THE SPEED OF LIGHT!

$$\Delta_v = V_e T \frac{m_0}{m_1}$$

UNE HISTOIRE
– TRÈS BRÈVE
– DRÔLEMENT BIEN ILLUSTRÉ –
DE
L'HÉLICE

PAR
MARCEL
DUCHAMP

WE BEGIN
WITH ZE BEGINNING –
WITH
ARCHIMEDES.

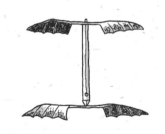

IN ZE THIRD CENTURY B.C.,
APPLYING ZE PRINCIPLE OF
SPIRAL MOVEMENT IN SPACE,
HE INVENTS ZE
"ARCHIMEDES SCREW"
TO LIFT WATER
FOR IRRIGATION AND TO
BAIL BOATS.

NEXT,
IN 1493 –
WE SAID SHORT, NON? –
LEONARDO ADAPTS ZE "SCREW"
FOR HIS SKETCH OF WHAT
WE NOW CALL ZE
HELICOPTÈRE.

THREE CENTURIES LATER, IN 1783,
ZE FRENCHMEN LAUNOY ET BIENVENU
INVENT A COAXIAL HELICOPTÈRE
CONSISTING OF TWO COUNTERROTATING
SETS OF TURKEY FEATHERS POWERED
BY A STRING WOUND AROUND THE
ROTOR SHAFT AND TENSIONED
BY A CROSSBOW.

ALMOST ONE HUNDRED YEARS LATER,
IN 1871, ALPHONSE PENAUD BUILDS HIS
"PLANOPHORE"–ZE GREATEST OF
RUBBER BAND-POWERED FLYING
MACHINES! ON AUGUST 18, HE FLIES
ZE PLANOPHORE 181 FEET IN 11 SECONDS
IN ZE JARDIN DES TUILERIES.

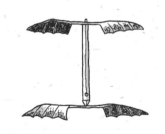

NOW IT IS 1878. ZE PÈRE OF LES
FRÈRES WRIGHT GIVES ZE BOYS A
TOY PLANOPHORE. ZE WRIGHTS
GO ON, IN 1901-05, TO INVENT
ZE PROTOTYPICAL
MODERN PROPELLER.

TO MAKE IT,
ZE WRIGHTS WATCHED BIRDS,
AND DISCOVERED THAT
A PROPELLER IS
ESSENTIALLY THE SAME
AS A WING.

USING WIND TUNNELS TO TEST
BOTH WINGS AND PROPELLERS, ZEY
SAW THAT ZE RELATIVE ANGLE OF
ATTACK FROM ZE FORWARD MOVEMENT
OF AN AIRCRAFT WAS DIFFERENT FOR
ALL POINTS ALONG ZE LENGTH OF ZE
PROPELLER BLADE – THUS IT WAS
NECESSARY TO INTRODUCE A
TWIST ALONG ITS LENGTH.

ET VOILÀ –
ZE THING
ITSELF.

REGARDEZ ÇA.
IT REPRESENTS
A CHALLENGE AND A REBUKE
TO ALL OF US WHO ARE INVOLVED
WITH ZE ENTERPRISE
OF CONSTRUCTION –
WITH ZE ENTERPRISE
OF ART.

TELL ME, LÉGER, CAN YOU DO BETTER THAN THIS?

AND YOU, BRANCUSI. CAN YOU DO BETTER?

NU ŞTIU, MARCEL. IT IS AN ENVIABLE FORM, YES.

WHAT CAN I SAY BUT, FOR ME, EVERYTING I DO IS SEEKING AFTER SUCH FORM. FROM MY VERY FIRST BIRD, ZE PASAREA MAIASTRA — I VISHED TO RESOLVE ZE MADDENINGLY DIFFICULT PROBLEM OF GETTING ALL ZE FORMS INTO ONE FORM.

A TRUE FORM SHOULD SUGGEST INFINITY. ZE SURFACES SHOULD LOOK AS THOUGH ZEY VENT ON FOREVER, AS THOUGH ZEY PROCEEDED OUT FROM ZE MASS INTO SOME PERFECT AND COMPLETE EXISTENCE.

IT IS VHAT I VISH FOR MY BIRDS. EN VERITÈ, JE N'AI CHERCHÉ PENDANT TOUTE MA VIE QUE L'ESSENCE DU VOL. LE VOL, QUEL BONHEUR! THE AIM IS A PROJECT OF BIRD WHICH, WHEN ENLARGED, WILL FILL THE SKY.

W. BENJAMIN
PRÉSENTS

— ALLEGORY —
THE HERMENAUT'S ART

WONDERFUL TRANSPORMATIONS! STARTLING ILLUSIONS! PRODIGIES OF ILLUMINATION!

INCOMPREHENSIBLE WONDERS IN EXPERIMENTAL PHILOSOPHY

NOT ATTEMPTED BY ANY OTHER INTELLECTUAL

...AND SO THE INTRODUCTION OF TIME INTO THE FIELD OF SEMIOTICS PERMITS THE INCISIVE, FORMAL DEFINITION OF THE RELATIONSHIP BETWEEN SYMBOL AND ALLEGORY.

VHEREAS IN THE SYMBOL DESTRUCTION IS IDEALIZED AND THE TRANSFIGURED FACE OF NATURE IS FLEETINGLY REVEALED IN THE LIGHT OF REDEMPTION, IN ALLEGORY THE VIEWER IS CONFRONTED VIZ THE FACIES HIPPOCRATICA OF HISTORY AS A PETRIFIED, PRIMORDIAL LANDSCAPE.

EVERYTHING ABOUT HISTORY THAT, FROM THE VERY BEGINNING, HAS BEEN UNTIMELY, SORROWFUL, UNSUCCESSFUL, IS EXPRESSED IN A FACE — OR RATHER IN A DEATH'S HEAD.

PARADOXICALLY, THIS FINAL STASIS OR PETRIFIED STILLNESS IS THE RESULT OF A FATAL ACCELERATION, SIMILAR TO THAT WHICH AFFECTS US WHEN WE ARE TRANSPORTED AT GREAT SPEEDS — THE COGNITIVE BLUR THAT RESULTS FROM ONE THING BLENDING INTO ANOTHER, AND ANOTHER, AND STILL ANOTHER.

AS THOSE WHO ARE FALLING TURN SOMERSAULTS AS THEY PLUNGE, AND UNIMPED ED MUST EVENTUALLY ACHIEVE DIZZYING VELOCITIES, SO WOULD THE ALLEGORICAL INTENTION FALL, FROM EMBLEM TO EMBLEM, INTO THE DIZZINESS OF ITS OWN BOTTOMLESS DEPTHS.

-GREAT CHAMPION ENTERTAINMENT-
"THE PERFECTION OF FUN!"

THE ART OF
SCRIMSHAW

AS DEMONSTRATED BY
CAPTAIN AHAB
OF NANTUCKET, MA.

HARK TO OLD AHAB, LADS, AND HE'LL TEACH YE HOW MEN HAVE PRACTICED THE SCRIMSHANDER'S ART SINCE VESSELS FIRST VENTURED FORTH UPON THE SEA.

A STANDS FOR ATOM; IT IS SO SMALL NO ONE HAS EVER SEEN IT AT ALL.

B STANDS FOR BOMBS; THE BOMBS ARE MUCH BIGGER, SO, BROTHER, DO NOT BE TOO FAST ON THE TRIGGER.

F STANDS FOR FISSION; THAT IS WHAT THINGS DO WHEN THEY GET WOBBLY AND BIG AND MUST SPLIT IN TWO.

AND JUST TO CONFOUND THE ATOMIC CONFUSION, WHAT FISSION HAS DONE MAY BE UNDONE BY FUSION.

H HAS BECOME A MOST OMINOUS LETTER; IT MEANS SOMETHING BIGGER, IF NOT SOMETHING BETTER.

"VELL, YOU KNOW, AFTER THE VAR — THE SECOND VUN — I CAME TO THE U.S., AND THE V-2 CAME TOO.

$\Delta_v = v_e I$

"I — VE — VENT TO NEW MEXICO, AND VIZ THE HELP OF THE MILITARY, BEGAN NEW TESTS — TESTS OF THE ROCKET. JA, LIKE AT PENNEMÜNDE.

$\Delta_v = v$

"MY DREAM WAS MANNED SPACEFLIGHT — MAN IN SPACE. FOR IT IS ONLY WHEN IT REACHES SPACE THAT THE ROCKET ESCAPES THE PARABOLIC CURSE OF GALILEO — IT IS THEN THAT IT MAY REACH VELOCITIES OF POTENTIALLY INFINITE MAGNITUDE. IT IS THEN THAT THE ROCKET BECOMES FIRE!

$\Delta_v = v_e$

"BUT TO PREPARE FOR SUCH A DREAM VE FIRST HAD TO TEST, *NICHT WAHR?* — TEST CONDITIONS IN SPACE. VE BEGAN VIZ APES, *NATÜRLICH* — VIZ MONKEYS.

$\Delta_v = v_e$

THE FIRST MONKEY TO RIDE A V-2 WAS *ALBERT*, A RHESUS MONKEY. IN 1948 ALBERT REACHED AN ALTITUDE OF 39 MILES. UNFORTUNATELY, HE SUFFOCATED TO DEATH.

IN 1949 *ALBERT II* RODE THE V-2 83 MILES UP — VELL PAST THE KÁRMÁN LINE WHICH MARKS THE BEGINNING OF SPACE. THEREFORE THIS ALBERT WAS THE FIRST MONKEY IN SPACE! SADLY, HE TOO DIED — ON IMPACT UPON HIS REENTRY.

THAT SAME YEAR, A CYNOMOLGOUS MONKEY, ALBERT III — JA, WE LIKED THE NAME ALBERT — REACHED ALMOST 82 MILES, THEN ALSO DIED ON IMPACT.

TECHNICALLY, THAT VUS THE LAST MONKEY V-2 FLIGHT. BUT SEPARATELY, MONKEYS AND V-2S VENT ON TO GREAT THINGS!

$\Delta \quad \frac{m_0}{m_1}$

YOU VANT MORE MONKEYS? VELL, VE HAVE *ABLE* AND *MISS BAKER*, FOR EXAMPLE.

ABOARD A JUPITER ROCKET IN 1959, THEY BECAME THE FIRST LIVING BEINGS TO SUCCESSFULLY RETURN TO EARTH AFTER BEING IN SPACE.

RIDING THE ROCKET, THEY EXCEEDED VELOCITIES OF 160,000 KM/H AND VIZSTOOD AS MUCH AS 38 G!

THEN, *NATÜRLICH*, WE HAVE *HAM*. JA, *DER GROSSE HAM!* THE FIRST HOMINID IN OUTER SPACE. IN 1961 HE VENT UP IN A MERCURY REDSTONE. HE VUS NO MERE PASSENGER — NO, HE VUS VORKING DIALS AND LEVERS AS HE FLEW.

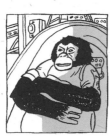

HIS FLIGHT LASTED 16 MINUTES 39 SECONDS. UPON HIS RETURN, HIS NOSE VUS BRUISED, BUT OTHERVISE HE VUS OK. VUT A HERO VUS HAM! LATER HE VUS IN A MOVIE VIZ THE FAMOUS *EVEL KNIEVEL*.

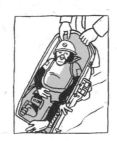

AND THE V-2? VELL, THE V-2 BECAME THE BASIS FOR THE REDSTONE ROCKET, VHICH BECAME THE JUPITER, VHICH BECAME THE SATURN.

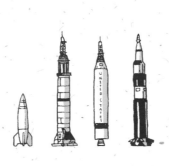

THE SATURN, YOU KNOW, VUS THE ROCKET VE USED IN THE APOLLO PROGRAM. SO JA, *ARMSTRONG UND ALDRIN* — MAN WALKED ON THE MOON THANKS TO THE V-2!

bzz
≈ Kr ackle ≈

WELL,
THANKS,
DR. VON BRAUN!

FOLKS,
THIS IS WALT DANGERFIELD
AGAIN, AND I'M GETTING WORD
THAT CAPT. JOE KITTINGER
IS ABOUT IS TO GO
UP IN HIS BALLOON.
LET'S WATCH,
SHALL WE?

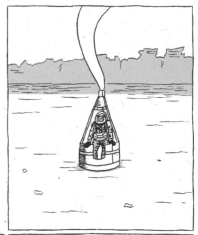

THAT'S THE EXCELSIOR III
THERE, FOLKS,
THE PREMIERE U.S. AIR FORCE
HELIUM BALLOON.
SEE IT EXPANDING AS IT
RISES? THE GAS INSIDE IS LESS
DENSE THAN THE AIR OUTSIDE,
SO UP SHE GOES.
THE GOOD OL' PRINCIPLE OF
BUOYANCY, AS FORMULATED
BY ARCHIMEDES
WAY BACK WHEN...

HOO DE HOO DE HOO,
JOE'S AT
102,800 FEET.
THAT'S ALMOST
20 MILES UP, FOLKS!
AND IF THAT'S
NOT ENOUGH,
WATCH WHAT JOE
DOES NOW:

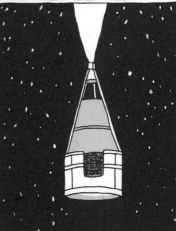

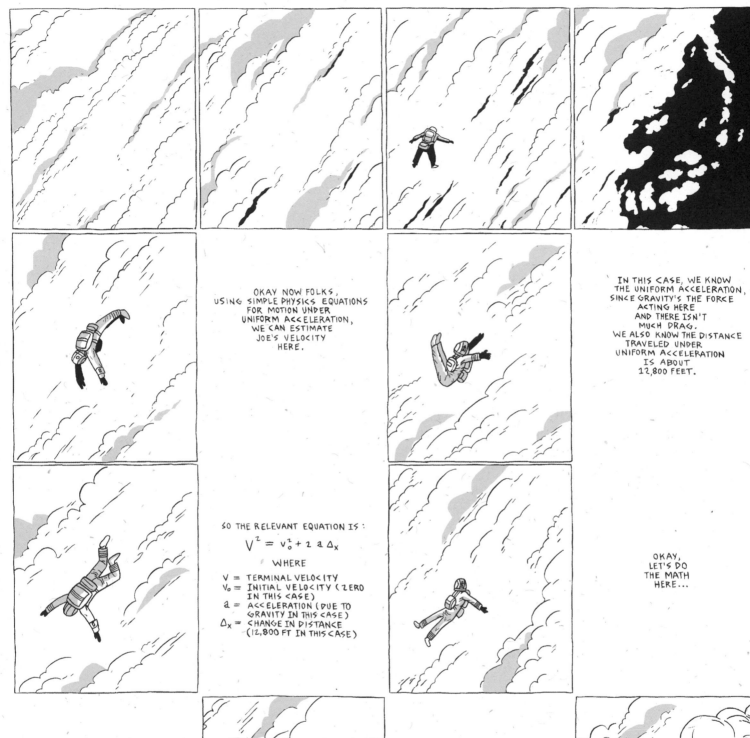

OKAY NOW FOLKS, USING SIMPLE PHYSICS EQUATIONS FOR MOTION UNDER UNIFORM ACCELERATION, WE CAN ESTIMATE JOE'S VELOCITY HERE.

IN THIS CASE, WE KNOW THE UNIFORM ACCELERATION, SINCE GRAVITY'S THE FORCE ACTING HERE AND THERE ISN'T MUCH DRAG. WE ALSO KNOW THE DISTANCE TRAVELED UNDER UNIFORM ACCELERATION IS ABOUT 12,800 FEET.

SO THE RELEVANT EQUATION IS:

$$V^2 = v_0^2 + 2\,a\,\Delta_x$$

WHERE

V = TERMINAL VELOCITY
v_0 = INITIAL VELOCITY (ZERO IN THIS CASE)
a = ACCELERATION (DUE TO GRAVITY IN THIS CASE)
Δ_x = CHANGE IN DISTANCE (12,800 FT IN THIS CASE)

OKAY, LET'S DO THE MATH HERE...

GOT IT! JOE'S THEORETICAL TOP SPEED, FOLKS, COMES IN AT ABOUT 905 FT/S OR 615 MPH.

A FAIR CLIP, NO? NOW, WE KNOW FROM GALILEO THAT IF NOT STOPPED, A FALLING BODY WILL OVER TIME DEVELOP SOME PRETTY FEARSOME VELOCITIES. SO IT'S A GOOD THING JOE'S GOT A

AH, JOE,
YOU GET ME
EVERY
TIME.

WELL, FOLKS,
BACK DOWN THERE ON EARTH
I SEE THE BIG SHOW
I WAS TELLING YOU ABOUT
IS SETTING UP OUTSIDE
THE MERC.
LEMME READ
THAT PSA
NOW:

AHEM.
"AT THE RACECOURSE IN KENTON,
TODAY FROM 6:00 AM TILL MIDNIGHT,
PERSONNEL IS BEING HIRED
FOR THE
THEATRE OF OKLAHOMA!
THE GREAT THEATRE OF OKLAHOMA
IS CALLING YOU!
IT'S CALLING YOU TODAY!
IF YOU MISS
THIS OPPORTUNITY,
THERE WILL NEVER
BE ANOTHER!

ANYONE THINKING OF HIS
FUTURE, YOUR PLACE IS WITH US!
ALL WELCOME!
ANYONE WHO WANTS TO BE
AN ARTIST,
ANYONE WHO WANTS TO BE
AN ASTRONAUT,
STEP FORWARD!
WE ARE THE THEATRE THAT HAS
A PLACE FOR EVERYONE, EVERYONE IN
HIS PLACE! IF YOU DECIDE TO JOIN
US, WE CONGRATULATE YOU HERE AND
NOW! BUT HURRY, BE SURE NOT
TO MISS THE MIDNIGHT DEADLINE!
WE SHUT DOWN AT MIDNIGHT, NEVER TO
REOPEN! ACCURSED BE ANYONE
WHO DOESN'T BELIEVE US!
KENTON
HERE WE COME!"

HOO DE HOO DE HOO,
THAT
SOUNDS LIKE
FUN,
DOESN'T IT?
LOOK,
THE
TENT'S
GOING UP—

AND LISTEN,
THE
LADIES
ARE
CALLING:

LOOKS LIKE
FOLKS
ARE
HEADING OVER...
YEP,
THE MERC'S
SHUT DOWN
FOR
THE DAY...

AND ME?
WELL, FOLKS, I'M
STARTING TO MOVE OUT OF RANGE...
GOT A LOT OF EARTH
TO COVER,
IF YOU KNOW WHAT I MEAN...
ALL AROUND THE WORLD
THEY'RE WAITING FOR
THE GOOD WORD...
SO HELLO,
PENNEMÜNDE!
HOWDY,
NOVAYA ZEMLYA!
ENEWETAK,
HERE I COME!

16

I CAN SEE
THEY'RE SADDLING UP
DOWN BELOW...
GETTIN' READY TO LAUNCH...
CAPTAIN JOE'S
GETTIN' READY TO GO UP AGAIN...
ASTRONAUT GAGE,
ASTRONAUT BEUYS,
ASTRONAUT AHAB
AND ALL...
GODSPEED, BOYS...

OVER AT
SNAKE RIVER,
OL' EVEL'S
ABOUT TO
BLAST OFF...
LET'S LISTEN IN
A MINUTE...

WHY DO I JUMP?
WELL, YOU COULD SAY IT'S OUT OF A KIND
OF SOLIDARITY, MAYBE. SOLIDARITY WITH
ALL THE — WELL, WITH ALL THE
UNTIMELY, SORROWFUL,
UNSUCCESSFUL EXPERIENCES OF...
LACK OF FREEDOM,
IMPERFECTION,
BROKENNESS.

YOU COULD SAY
IT'S THE SUFFERING OF
CREATURELINESS
I'M REPRESENTIN'—
THE, YOU KNOW,
CREATURELINESS
OF
SUFFERING.

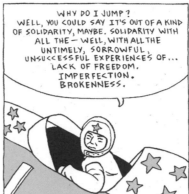
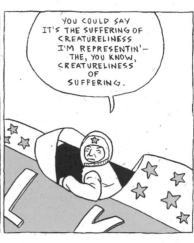

WHEN I JUMP, I LIKE TO THINK
I'M TRYIN' TO PENETRATE TO THE
IMMANENT STATE OF PERFECTION
LATENT IN THE CLUMSIEST AND MOST
HELPLESS EXPERIMENTS OF A
DECADENT AGE. I WANT TO RESCUE
'EM, REDEEM 'EM EVEN—

— REDEEM 'EM NOT AS A METAPHOR,
NOT AS SOME SPELL
OF TRANSFIGURATION,
BUT AS, I DUNNO, A SIGNPOST,
SOMETHING INDICATIN' A DIRECTION:
UP.

... THANKS,
EVEL!
AND
GODSPEED
TO YOU,
TOO.

WELL, FOLKS,
I'M STARTING TO BREAK UP.
BEFORE I MOVE OUT OF RANGE,
I WANT TO THANK YOU
FOR ALL YOUR
CARDS AND LETTERS...
YOUR
TEXTS AND TRANSMISSIONS...
LET'S TUNE IN TO A FEW
BEFORE I FADE OUT...
LET'S
SAMPLE,
JUST LIKE ONE OF THOSE
OLD-TIMEY
DJ'S...

"IF I
HAVE PERFORMED
ALCHEMY,
THEN IT WAS IN THE
ONLY WAY THAT IS
RELIABLE
NOWADAYS,
THAT IS,
UNWITTINGLY."

AND AT DEEP MIDNIGHT,
ALL THE GARDEN WAS LIGHTED
SUDDENLY AS BY A FLAME,
· AND FROM THE EAST,
SWIFT AS A FALLING STAR,
A BIRD OF FIRE
FLEW TOWARD THE APPLE TREE,
AND HER PLUMAGE
WAS BRIGHTER THAN THE SUN,
AND TURNED
NIGHT INTO DAY.

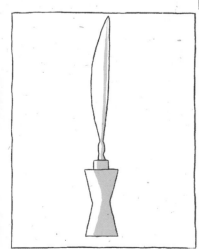

AS WEST AND EAST
IN ALL FLATT MAPS —
 AND I AM ONE—
 ARE ONE;
SO DEATH
 DOTH TOUCH THE RESURRECTION.

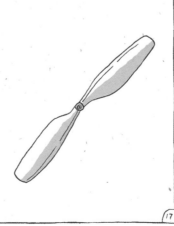

PICKIN' UP COURAGE
 TO KEEP FROM LEAVIN'
WAY OUT WEST IN NO MAN'S LAND

17

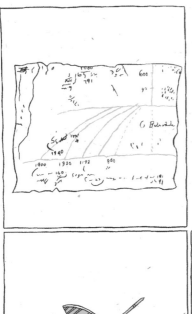

"IF THE CONTENT OF CONSTRUCTION MUST BE THE RELATIVITY AND MUTUALITY OF FORCES IN THE GRAVITATIONAL FIELD, THEN TO ACHIEVE CLARITY, RIGOR, PARTICULARITY, UNITY, AND OPENNESS, THE MODE OF PRESENTATION MUST BE PUSHED TO THE POINT OF ITS VERY METAMORPHOSIS AND ERASURE— TO THE HORIZON OF UNKNOWABILITY AND UNUTTERABILITY...

$$\Delta_v = v_e \ln \frac{m_e}{m_1}$$

... THE VEHICLE MUST REACH UNHEARD-OF VELOCITIES AT THE SAME TIME AS IT STANDS DIRECTLY BEFORE US."

IT'S ALL LIFTING OFF, FOLKS... IT'S ALL RISING UP...

SO GET YOUR G-FACES ON, EVERYBODY. RATTLE THEM BUFFALO BONES. THE AIM TONIGHT IS ACCELERATION. WE'RE GONNA PITCH, YAW, AND ROLL...

THROTTLE UP? ROGER, THROTTLE UP.

THAR SHE BLOWS...

NOTES

P.2

The Fédération Aéronautique Internationale, founded in France in 1905, is the world governing body for air sports and aeronautics and astronautics world records, including manned vehicles (from balloons to spacecraft) and unmanned ones (such as model aircraft, e.g. Alphonse Pénaud's "Planophore" [see below]). This story is definitely not approved by the FAI.

P.3

Walt Dangerfield, the orbiting disc jockey, is borrowed from Philip K. Dick's 1965 novel *Dr. Bloodmoney, or How We Got Along After the Bomb*. In the novel, Walt Dangerfield's expedition to Mars is interrupted by a nuclear cataclysm that decimates the planet. Trapped in orbit around the earth, he transmits via radio to the few ragtag communities surviving below. "Hoo de hoo de hoo" is Dangerfield's peculiar catchphrase.

The No Man's Land ditty, as well as some of the lore cited by Dangerfield, appears in Robert Barr Smith's "Story of the Oklahoma Panhandle" at www.nomanslandbulldogs.com/historyofnomansland.

P.4

Kenton, Oklahoma is a real place—it sits on Rt. 325; there is rock art to be found nearby—though it is treated mostly fictitiously herein. The "Mercantile" or "Merc," also somewhat real, was indeed founded by Drew Barnum (nephew of P.T.) in 1898, and has served during its long life as a post office, natural history museum, and general store. It still exists today and is for sale. In 2006, M.D. Jackson drove through town and was struck by the place. He has expressed a desire to purchase the store, restore it to its past functions, and install his own work there. This story grants him that wish.

Pictured inside the Merc: model based on notebook sketch by Leonardo da Vinci of a theoretical helicopter, ca. 1486–1490; examples of scrimshaw; cast skull of Phineas Gage, death mask of William Blake; models of Fat Man and Little Boy, the atomic bombs dropped on Hiroshima and Nagasaki in August 1945; Brancusi Bird in Space; Soviet cosmonaut helmet; NASA astronaut boot; 2008 Nike limited-edition Evel Knievel commemorative sneaker; rubber-band-operated helicopter toy invented by French aviation pioneer Alphonse Pénaud in 1870; model of Wright Bros. Glider of 1902; model of V-2 rocket; model of U.S. Air Force X-15; and assorted works by the Merc's proprietor.

P.5

Items depicted on this page: prototypical Wright Bros. propeller, 1909; Brancusi's *Maiastra* (1910); 1960 Sunday *Peanuts* comic strip by Charles M. Schulz; page from the notebooks of Galileo (1564–1642) demonstrating the principle of projectile motion, i.e. the path of projectiles—rocks, missiles, rockets—follows a precise mathematical curve: the parabola; lunar footprint of astronaut Buzz Aldrin, July 20, 1969; footage of Air Force Lt. Colonel John Paul Stapp subjected to as much as 46.2 Gs (G = the force of gravity acting on a body on earth at sea level) while being accelerated at speeds reaching 632 mph along a 3,500-foot-long rocket sled track at Holloman Air Force Base in 1954. Over the course of his many runs on the rocket sled, Stapp suffered broken ribs and wrists, concussions, and in his eyeballs, "whiteouts" (blurry vision) and "redouts" (broken capillaries and hemorrhaging); poster for the movie *Evel Knievel* (1971, dir. Marvin J. Chomsky); 1960 issue of *LIFE* with cover photo of and article about Air Force Captain Joseph Kittinger's jump from the edge of space (see below); "Planophore" model airplane built by Alphonse Pénaud in 1871.

Postcards: Pennemünde, on the German Baltic, was the site of the German V-2 program during WWII. The V-2, developed under the supervision of Wernher von Braun, was the first ballistic missile and the first rocket to achieve sub-orbital spaceflight. Approx. 2,225 V-2s were launched by the Wehrmacht against Allied targets (most famously London) during WWII. Enewetak, an atoll in the Marshall Islands, was the site of 43 nuclear tests conducted by the U.S. from 1948 to 1958, including, on November 1, 1952, the test of the first hydrogen bomb, "Ivy Mike," developed by Edward Teller and his collaborators. Cape Canaveral in Florida is the launch site for manned U.S. spaceflights.

P.6

See below for Joseph Kittinger and Evel Knievel. Phineas Gage suffered his accident on September 13, 1848. For more on Phineas, see essays by Bill Arning and Tom Morton elsewhere in this book.

P.7

"Meeting of the Kenton Rocket Club. Guest lecturer: Wernher von Braun." Wernher von Braun headed the German V-2 program during WWII. He surrendered to the U.S. Army toward the end of the war, was transferred to Fort Bliss in Texas, and put in charge of U.S. Army V-2 tests. Von Braun worked on the American ICBM program before becoming director of NASA's Marshall Space Flight Center. Von Braun was the chief architect of the Saturn V rocket, the launch vehicle that propelled the Apollo 11 spacecraft to the moon in July 1969. Von Braun's dialogue is invented here.

The Tsiolkovsky Rocket Equation is named for Konstantin Tsiolkovsky, the Russian rocket scientist and pioneer of theoretical astronautics. Tsiolkovsky published his equation, which establishes the principles of rocket propulsion, in 1903.

Marcel Duchamp's lecture, though spurious, is adapted (and extremely condensed) from numerous sources.

P.8

Duchamp's challenge to Léger and Brancusi is based on an anecdote often related by Léger. According to the story, the three artists visited the Paris Air Show together, probably in 1912. After inspecting the gleaming new propellers on display, Duchamp turned to Léger and Brancusi and issued his challenge, recreated here. (For an interesting discussion of this, see Christoph Asendorf, "The Propeller and the Avant-Garde: Léger, Duchamp, Brancusi" in *Fernand Léger: The Rhythm of Modern Life 1911–1924*, (New York: Prestel-Verlag 1994).

Brancusi's response to Duchamp is adapted and emended from various interviews with and statements by the artist. The "Project of Bird" quotation, which gives this story its title, is from a statement for a catalogue accompanying a 1933 show at Joseph Brummer's gallery in New York. Brancusi was describing his hope to create a skyscraper-sized *Bird in Space*. See Friedrich Teja Bach, Margrit Rowell, Ann Temkin, et al, *Constantin Brancusi* (Philadelphia: Philadelphia Museum of Art, 1995), and Athena T. Spear, *Brancusi's Birds* (New York: New York University Press, 1969).

Walter Benjamin's lecture is adapted and emended from portions of the "Allegory and Trauerspiel" section of the *Ursprung des deutschen Trauerspiels (The Origin of German Tragic Drama)*, written 1924–25, first published 1928, first published in English 1977. Benjamin was analyzing the role of allegory in the baroque art of the sixteenth and seventeenth centuries, focusing specifically on the German "royal martyr dramas" called *Trauerspiel*. Despite this ostensibly narrow focus, Benjamin's compass was as usual much larger, which is why it seems appropriate to see him lecturing in Kenton. *Facies hippocratica* = the "Hippocratic face" or cachexia, the change produced in the face by impending death, first described by the ancient Greek physician Hippocrates. On Benjamin's chalkboard: a sketch of Paul Klee's *Angelus Novus*, 1920.

P.9–10

Einstein's lecture is adapted from his book *The Meaning of Relativity*, based on a series of lectures he delivered at Princeton in 1921, published in book form in 1922. In a chapter entitled "The Theory of Special Relativity," Einstein walks readers through a forbidding thicket of mathematical computations leading to the simple, elegant, profoundly world-altering $E = mc2$, which demonstrates, as he writes, that "Mass and energy are therefore alike; they are only different expressions of the same thing." The theoretical, then practical investigation of this equivalence led to the exploration of nuclear energy and the development of the atomic bomb.

P.10

The comic strip within a comic strip is based on a Sunday *Peanuts* strip of 1960 by Charles M. Schulz, glimpsed earlier in the Merc. In the original, Lucy, Linus, and Charlie Brown are studying clouds. In this version, title skewed to reflect Einstein's discovery, Einstein, J. Robert Oppenheimer, and Edward Teller have replaced the *Peanuts* cast.

Robert Oppenheimer was in charge of the Manhattan Project at Los Alamos during WWII. In letters written after the war, Oppenheimer recounted that the successful testing of the first atomic bomb at the Trinity test site on July 16, 1945 prompted him to thoughts of a poem by John Donne (see below) and, more famously, a passage from the Bhagavad Gita in which the god Krishna reveals his manifold aspects to Prince Arjuna and says: "Behold, I am become Death, the destroyer of worlds." See Richard Rhodes, *The Making of the Atomic Bomb* (New York: Simon & Schuster 1986).

The physicist Edward Teller worked on the Manhattan Project at Los Alamos and on the development of the hydrogen bomb during the late '40s and early '50s. The popular press dubbed him "the father of the hydrogen bomb." Teller, a complex, almost Shakespearean sort of character (as was Oppenheimer) whose long career was intertwined with the career of nuclear weapons, was the model for the deranged scientist Bruno Bluthgeld in Philip K. Dick's *Dr. Bloodmoney* and, reportedly, for the Dr. Strangelove character in Stanley Kubrick's film of the same name (unless the model was Wernher von Braun).

P.11

The rhyming alphabet on this page was written by Edward Teller as a sort of nuclear primer for children. Fat Man and Little Boy were fission bombs; hydrogen bombs such as Ivy Mike were fusion bombs.

P.12

The ruins depicted on this page are based on photographs of cities bombed during WWII (London, Tokyo, Dresden, Hiroshima). The limerick is from Thomas Pynchon's *Gravity's Rainbow* (1974), a novel about the V-2 rocket, among other things, the introductory epigraph to which is furnished by Wernher von Braun. Von Braun is also the source of the "rocket worked perfectly" quote, which he allegedly delivered to colleagues when the first V-2 landed on London in 1944.

P.13

Von Braun's words here are invented; the history of monkeys in space is derived from numerous sources. In addition to monkeys, mice, rats, dogs,

cats, spiders, frogs, worms, and other luckless creatures have been launched into space. For instance, the first tortoise in space was launched by the Soviet Union on September 14, 1968. A number of stamps issued in the former Soviet bloc commemorating the achievements of spacefaring animals may be viewed on the Internet— see, for example, www.spacetoday. org/Astronauts/Animals/Dogs. Ham the Chimp did indeed appear in the 1972 movie *Evel Knievel*. Phineas Gage, however, did not.

P.14–16

As part of research into high-altitude bailout, U.S. Air Force Captain Joseph Kittinger II made his ascent and subsequent jump on August 16, 1960. During his ascent, the right-handed glove in his pressurized suit failed; otherwise he landed unharmed. Kittinger filmed his jump, and footage may be viewed on YouTube—highly recommended. The math determining the Captain's rate of acceleration during his fall was calculated with the help of www.aerospaceweb.org.

Before his jump, Kittinger worked with John Paul Stapp on Stapp's G-force endurance experiments. An excellent account of Stapp, Kittinger, and their contemporary epigones may be found in Burkhard Bilger, "Falling," *The New Yorker*, 13 August 2007.

The Buoyancy Principle formulated by Archimedes in the 3rd century BC states that the buoyant force acting on a submerged object is equal to the weight of the fluid that is displaced by the object. Hot air balloons rise because the warmer air inside the balloon is less dense than the cooler air outside.

"Galileo...falling bodies": In his study of the motion of falling bodies, Galileo discovered that the acceleration of such bodies is constant. He demonstrated that an object released from a height starts with zero velocity and increases its speed over time. (Previously it had been believed that bodies, when released, instantaneously acquire a velocity that remains constant but is larger or smaller based on the weight of the object.)

P.16

The Nature Theatre of Oklahoma and the text of its solicitation are borrowed from Franz Kafka's unfinished novel

Der Verschollene (Amerika or The Man Who Disappeared), published posthumously 1927, first published in English 1946. (Text here based on Michael Hamburger's 1996 translation, published by New Directions 2002.) In the novel, young immigrant Karl Rossmann is lured to Oklahoma when he reads an advertisement bearing the alluring pitch duplicated on this page. "Kenton" here replaces "Clayton" in the original.

"Howdy, Novaya Zemlya!" Novaya Zemlya, receiving a shout-out here along with Peenemünde and Enewetak, is a Russian archipelago in the Arctic Circle and the site of Soviet nuclear tests from 1955–1990. During that time, 224 nuclear tests were conducted at Novaya Zemlya, with a total explosive energy equivalent to 265 megatons of TNT. On October 30, 1961, the Soviets detonated the "Tsar Bomba" hydrogen bomb at Novaya Zemlya. With an explosive yield of 50 megatons, the Tsar Bomba remains the largest and most powerful nuclear weapon ever detonated.

P.17

On September 8, 1974, Evel Knievel attempted to jump the Snake River Canyon in Idaho in his custom-built X-2 "skycycle," a combination motorcycle/rocket. Upon takeoff, one of the X-2's parachutes prematurely deployed and Knievel ended up being ferried slowly to the bottom of the canyon, where he narrowly escaped drowning in the Snake. Footage of the jump is available on YouTube.

Evel Knievel holds the Guinness World Record for the most broken bones: 35, including skull, nose, teeth, jaw, clavicle (right and left), arm (right and left), sternum, upper back (twice), lower back (twice), ribs (all), wrists (right and left), pelvis (three times), coccyx, hip, ball, and socket, right knee, left femur (three times), right shin, ankle (right and left), and toes (both feet).

Evel's dialogue here is invented, though it is inflected or ghosted by certain passages from Walter Benjamin's *Origin of German Tragic Drama*.

P.17–18

Quotations: "If I have performed alchemy..." Marcel Duchamp, quoted in Robert Lebel, *Marcel Duchamp*

(New York: Grove Press, 1959). "And at deep midnight..." Excerpted from W. Shedden Ralston, *Russian Folk-Tales*, Smith and Co., 1873, quoted in Spear, *Brancusi's Birds*. Spear: "The same magic golden bird and the same tale with variations are met in many other countries: Russia (as Zhar-ptista: firebird), in Czechoslovakia (as *Ptak Ohnivak*: Firebird), in Hungary, in Germany, in all northern European countries, in Italy, and through France, even across the Atlantic, in Missouri." In the Romanian variant of the tale, the bird is called *Pasarea Maiastra*. Brancusi's first bird sculptures were called *Maiastra*; they eventually evolved into the *Birds in Space*.

"As West and East..." From John Donne's poem "Flatt Maps." (See Tom Morton's essay for Donne and Robert Oppenheimer.)

"If the content of construction..." Adapted from Whitney Davis, *Pacing the World: Construction in the Sculpture of David Rabinowitch* (Cambridge, MA: Harvard University Press, 1996).

Dangerfield's "pitch, yaw, and roll" plays off the three angles of rotation in three dimensions about a vehicle's center of mass in flight dynamics. Dangerfield's "Roger, throttle up" echoes the last air-to-ground communication received from the Space Shuttle *Challenger* before it broke apart on January 28, 1986.

—David Tompkins, 2009

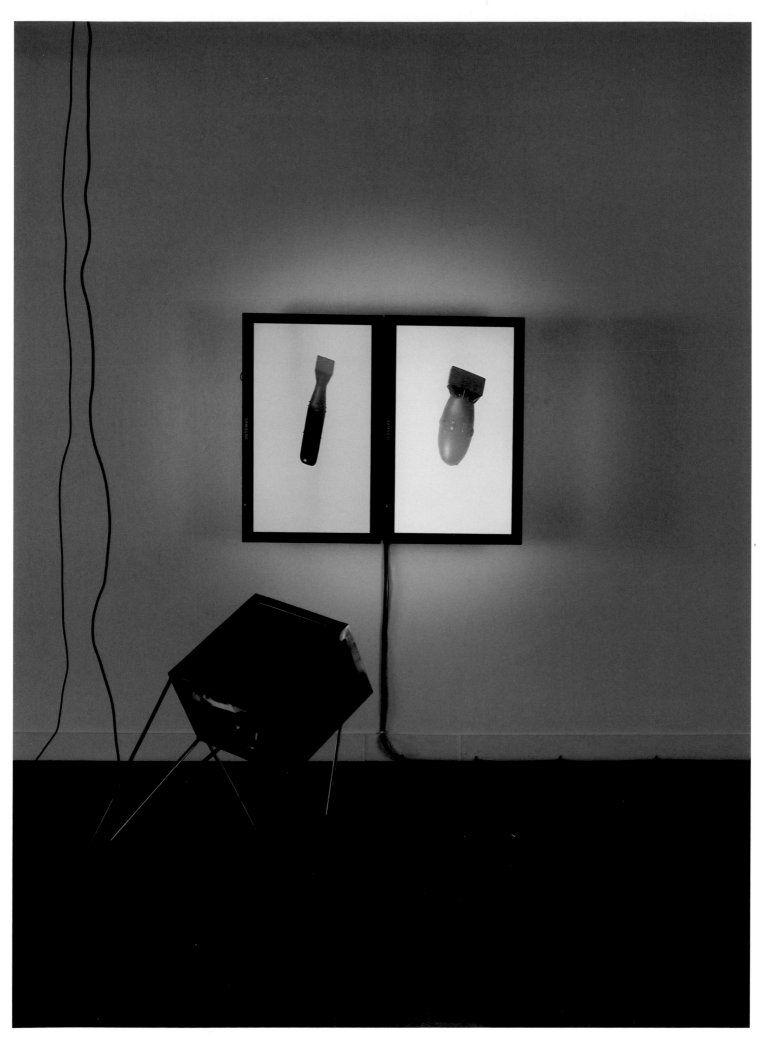

Kittinger and *Little Boy and Fat Man*

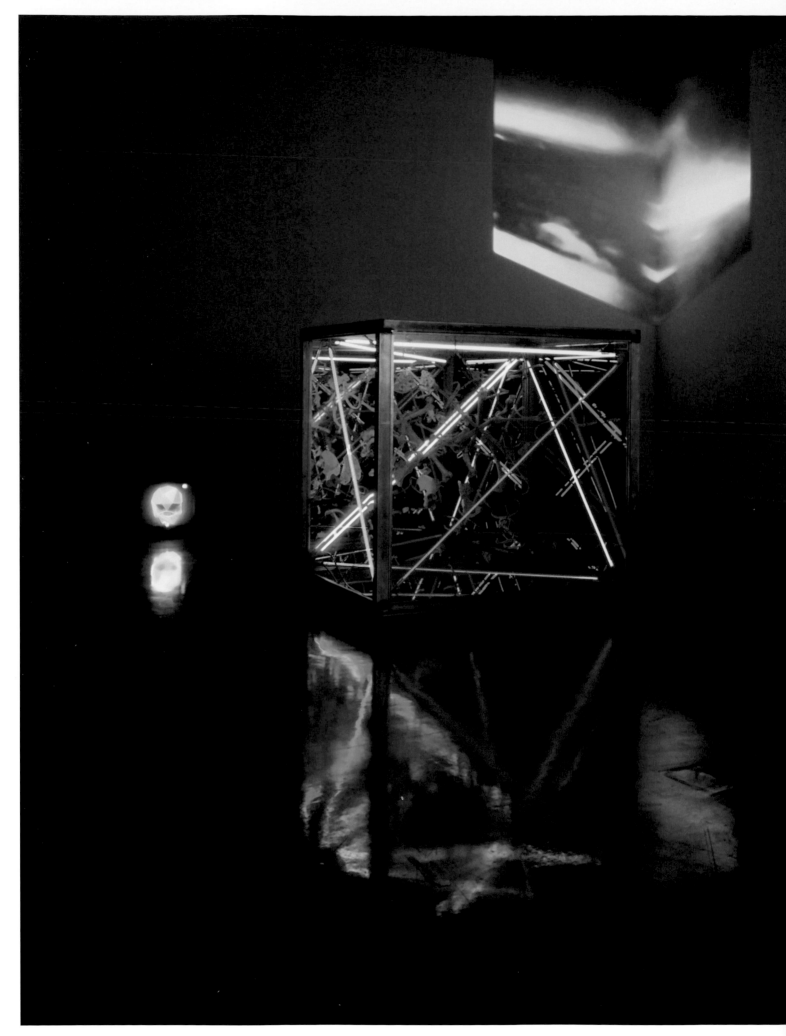

Metamorphosis, Tensegrity Biotron, Vertigo, Kittinger, and *Mapping the Studio (Fat Chance Colonel John Stapp)*

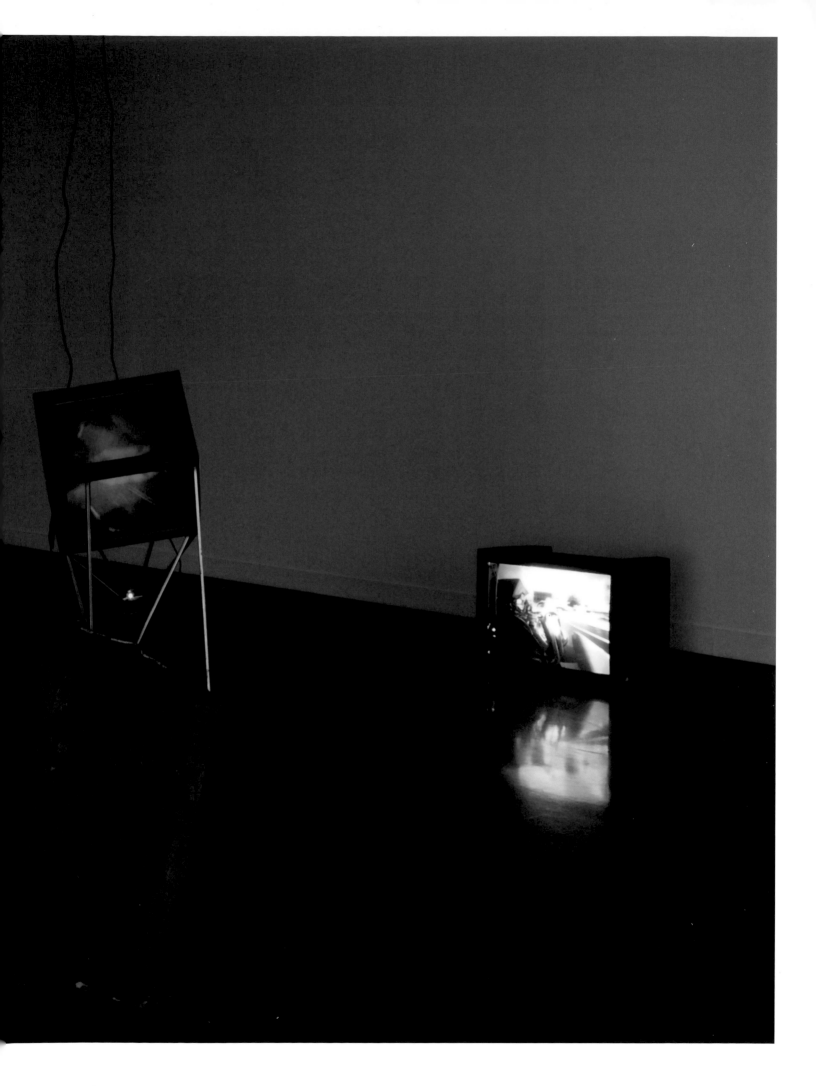

Playing Squash, Los Alamos, New Mexico, Kittinger, Pilgrimage, and *Tensegrity Biotron*

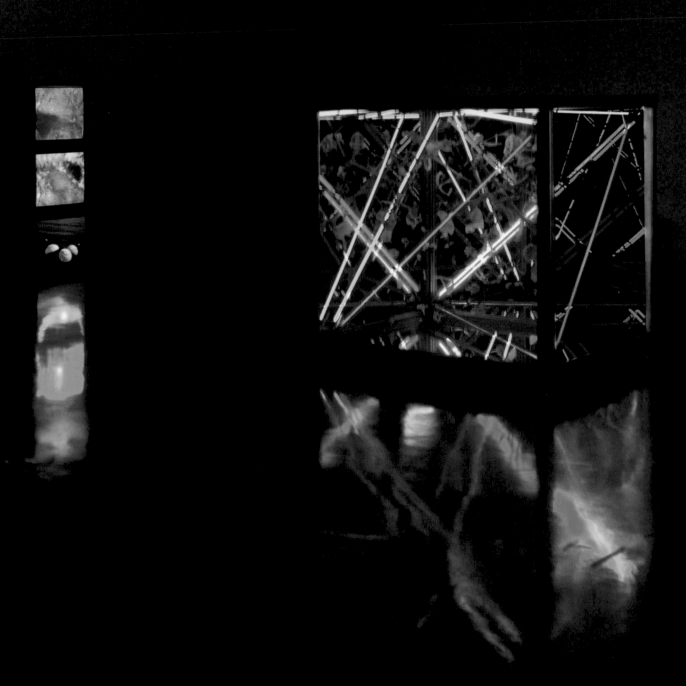

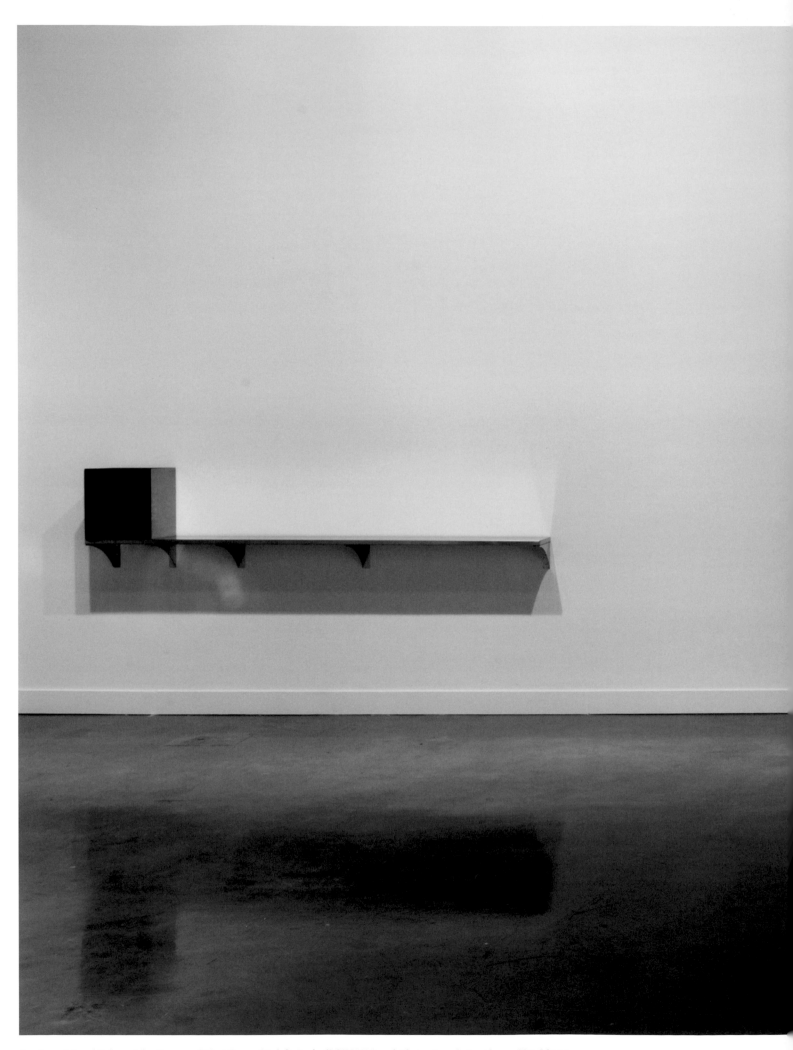

Luminary 1A and Colossus (after Borges and The Library of Babel), Bucky (ROYGBIV), and *Playing Squash, Los Alamos, New Mexico*

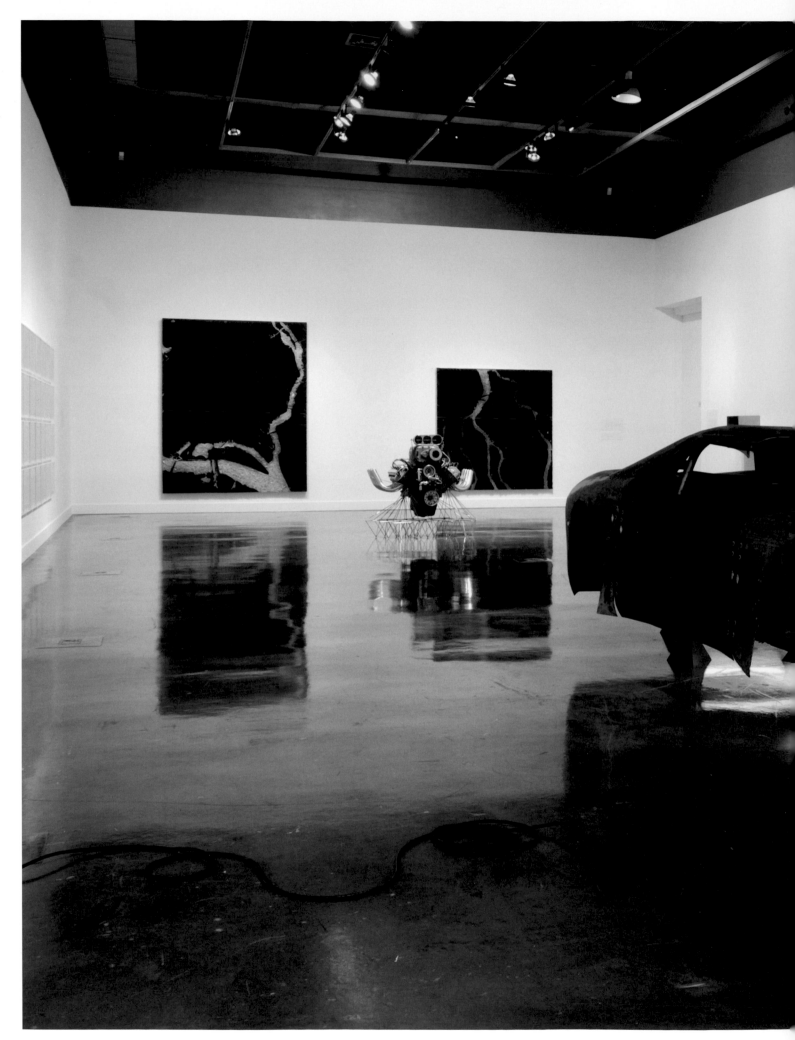

The Lower 48, August 6th, 1945, Heart of Prometheus, Chariot II—I Like America and America Likes Me, Bucky (ROYGBIV), and *Study Collection*

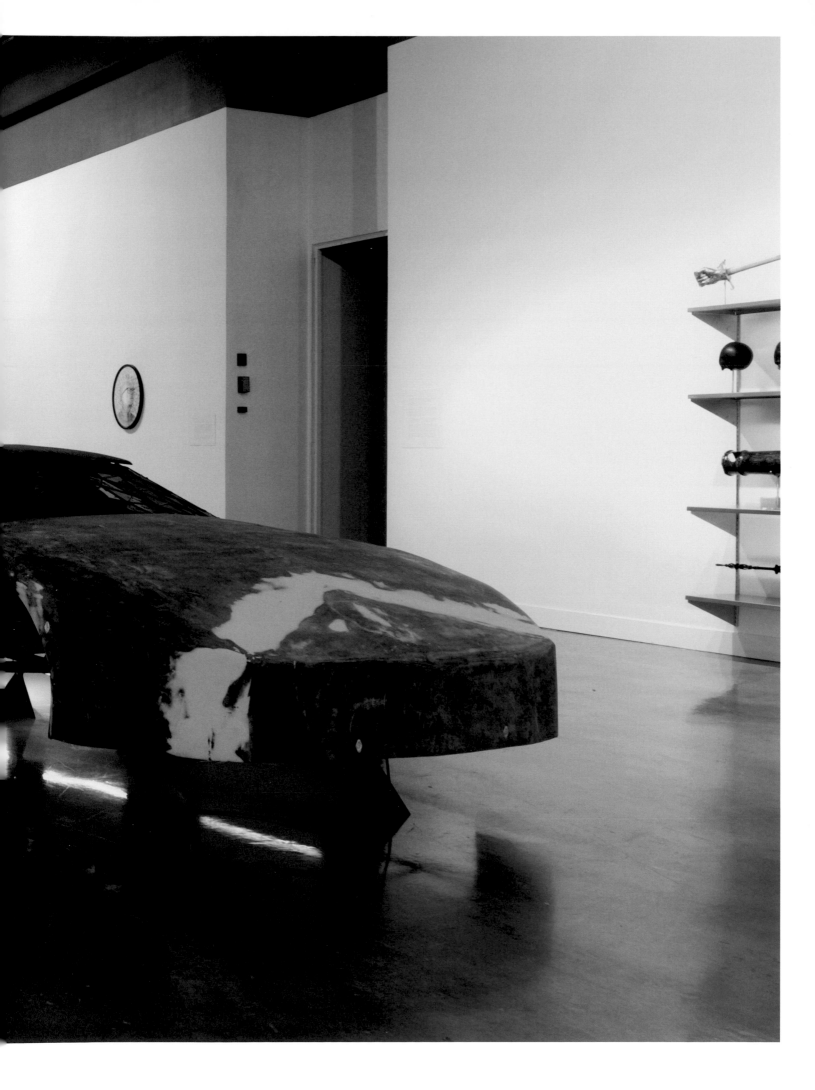

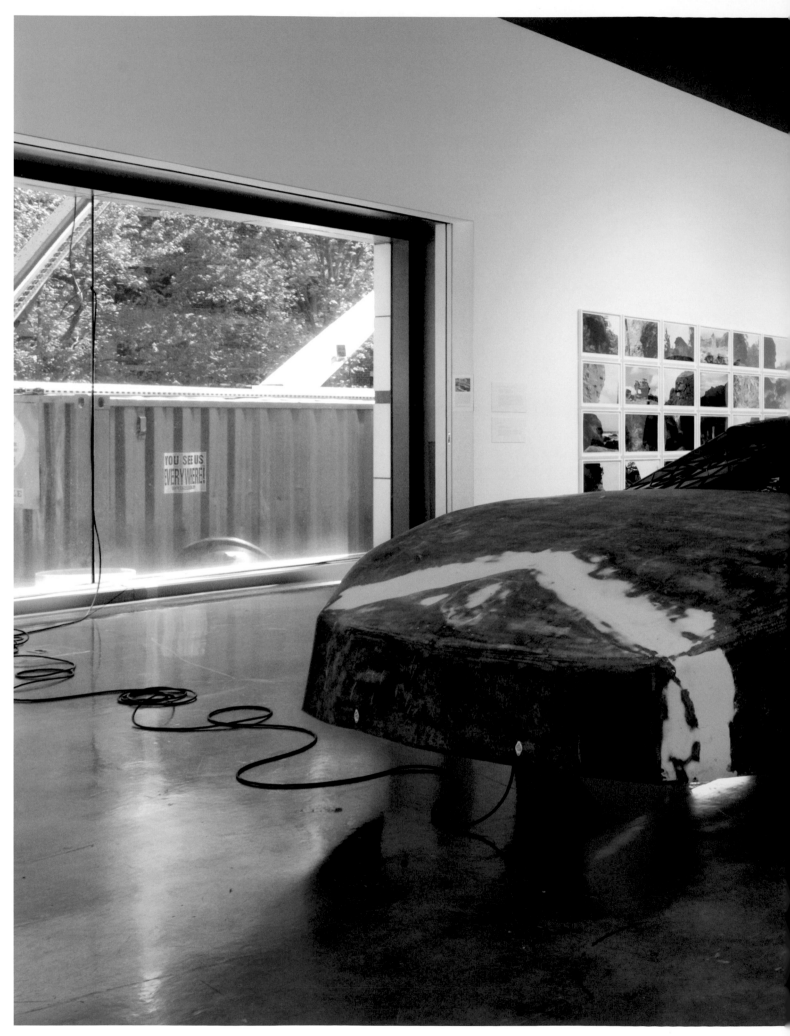

Chariot II—I Like America and America Likes Me, The Lower 48, August 6th, 1945, and *Heart of Prometheus*

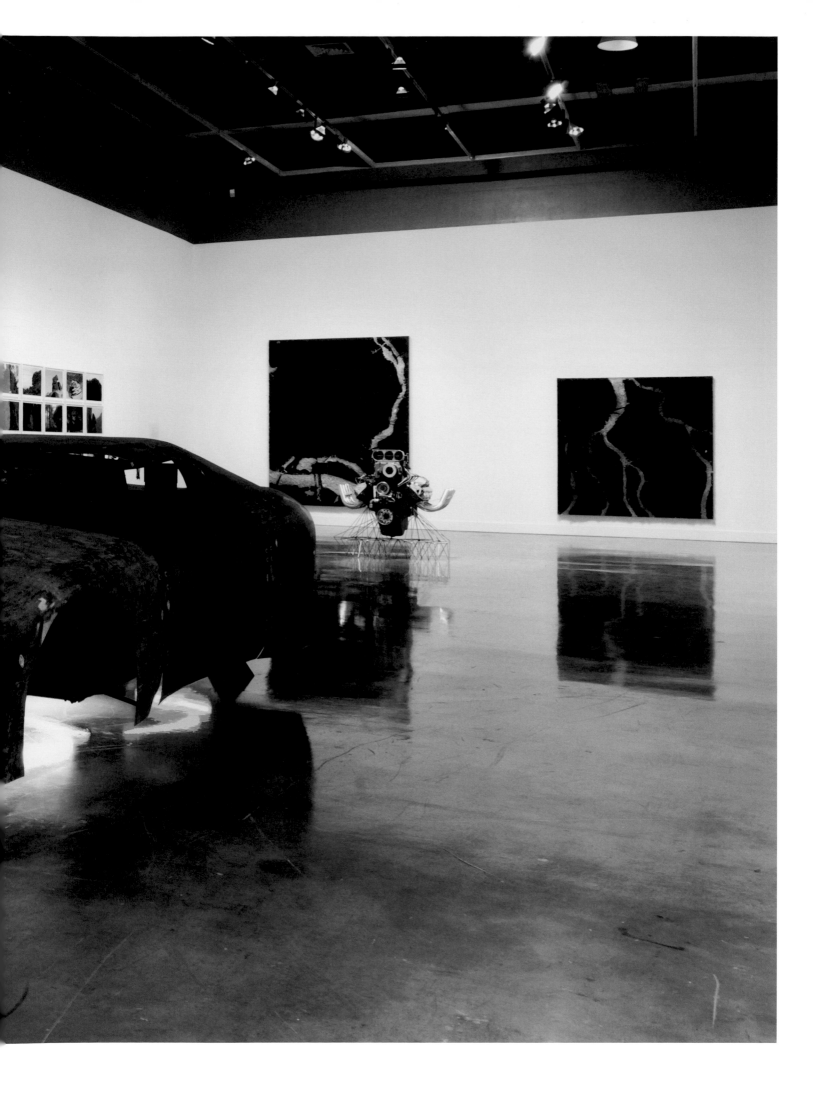

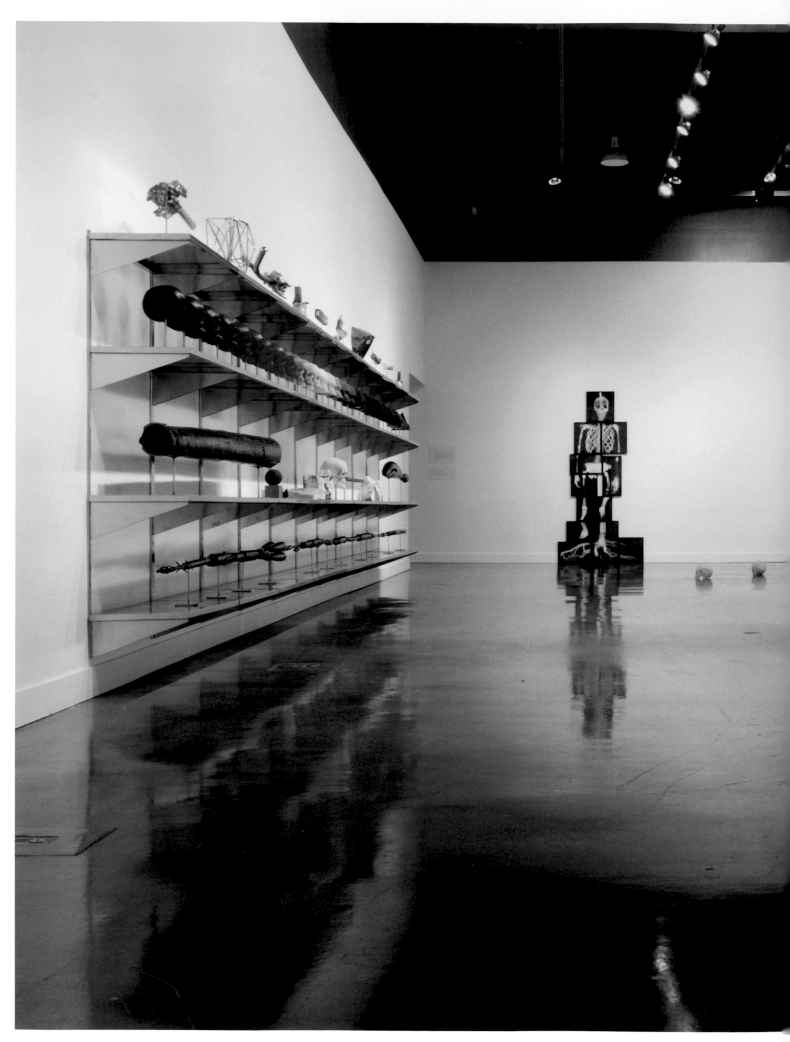

Study Collection, Missing Link (X-Ray), Against the Mythology of Linearity, Lonesome Soldier, Chariot II—I Like America and America Likes Me,
and *Dance of Destruction (featuring "Lady Liberty" as Shiva, Wovoka, Eleanor, and Jim Jones)*

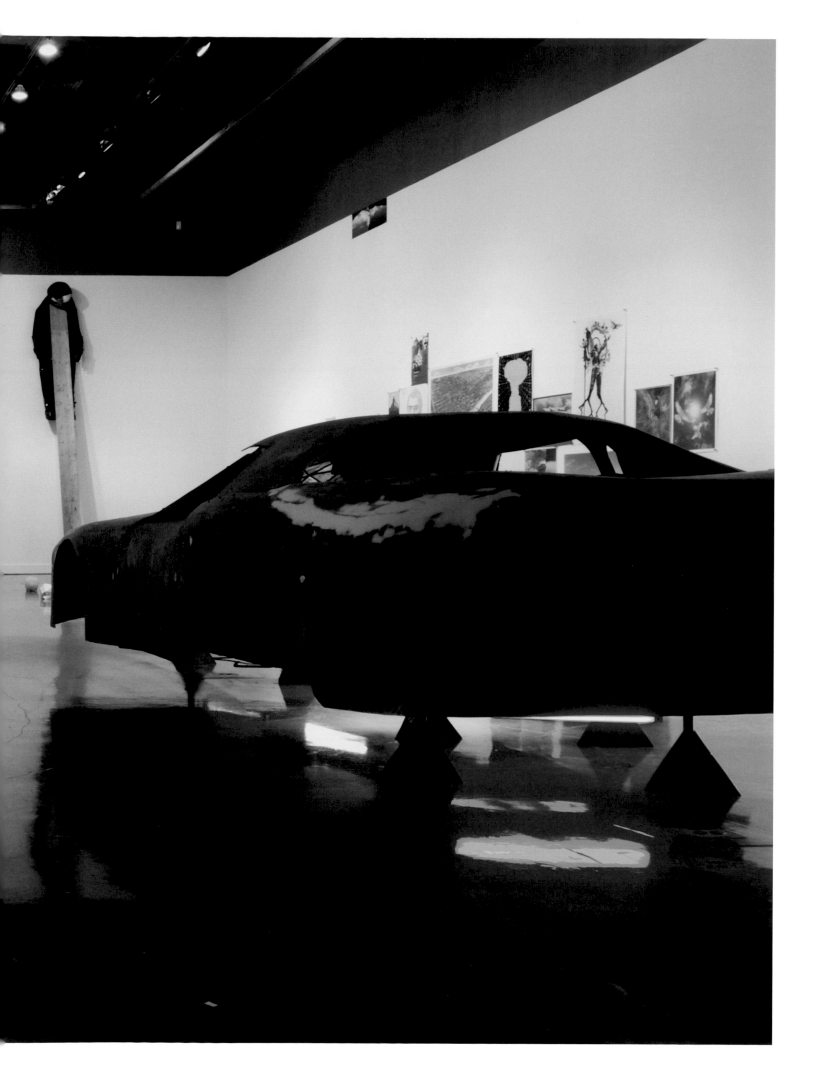

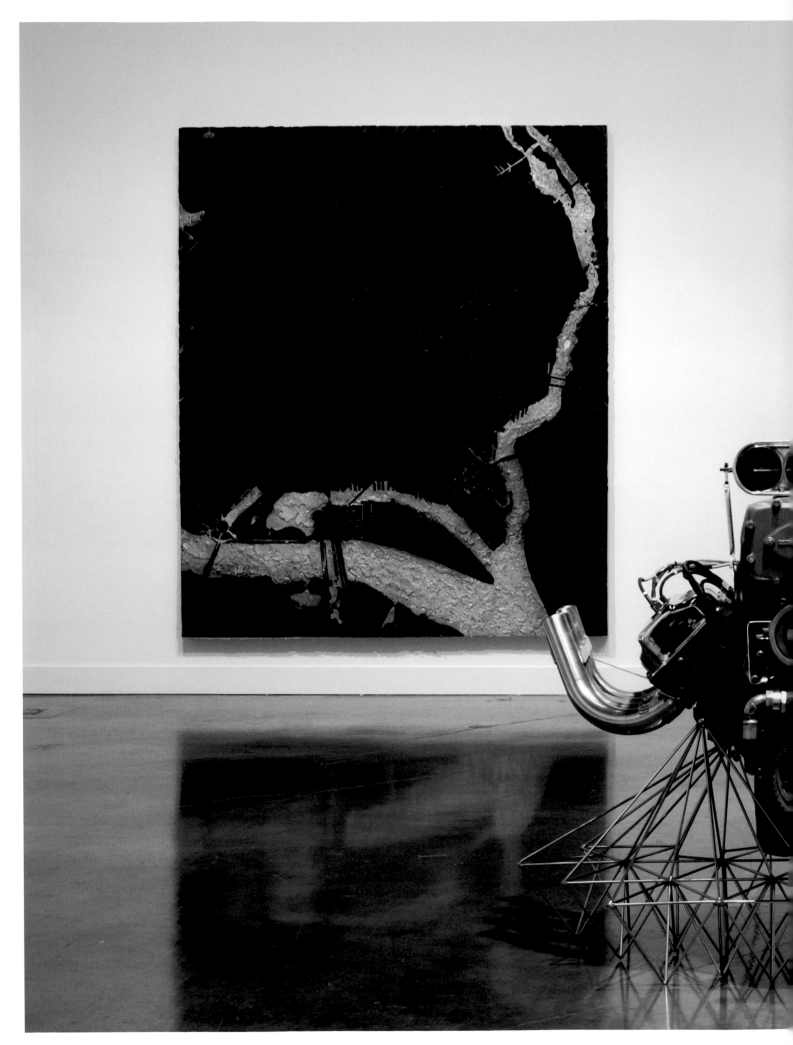

August 6th, 1945 and *Heart of Prometheus*

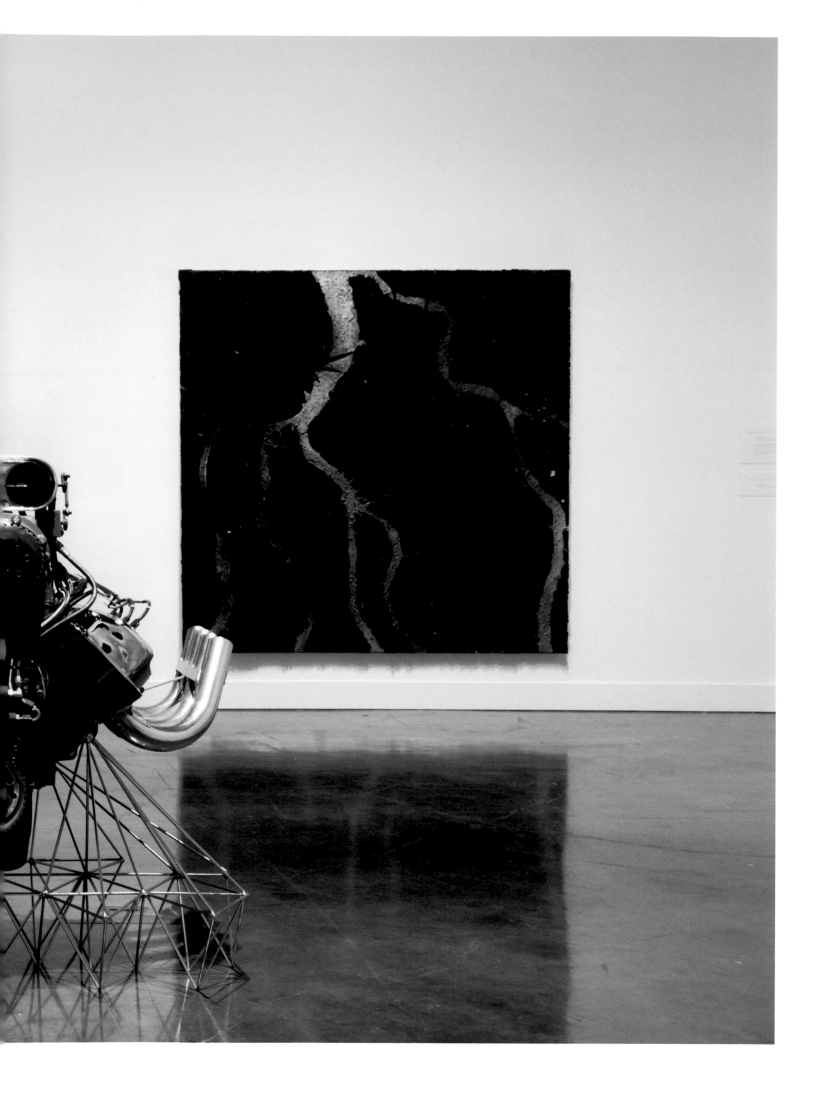

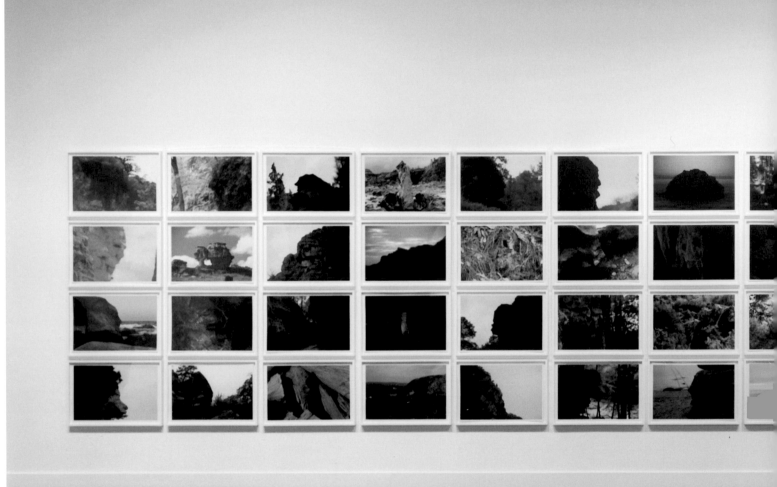

The Lower 48 and *Heart of Prometheus*

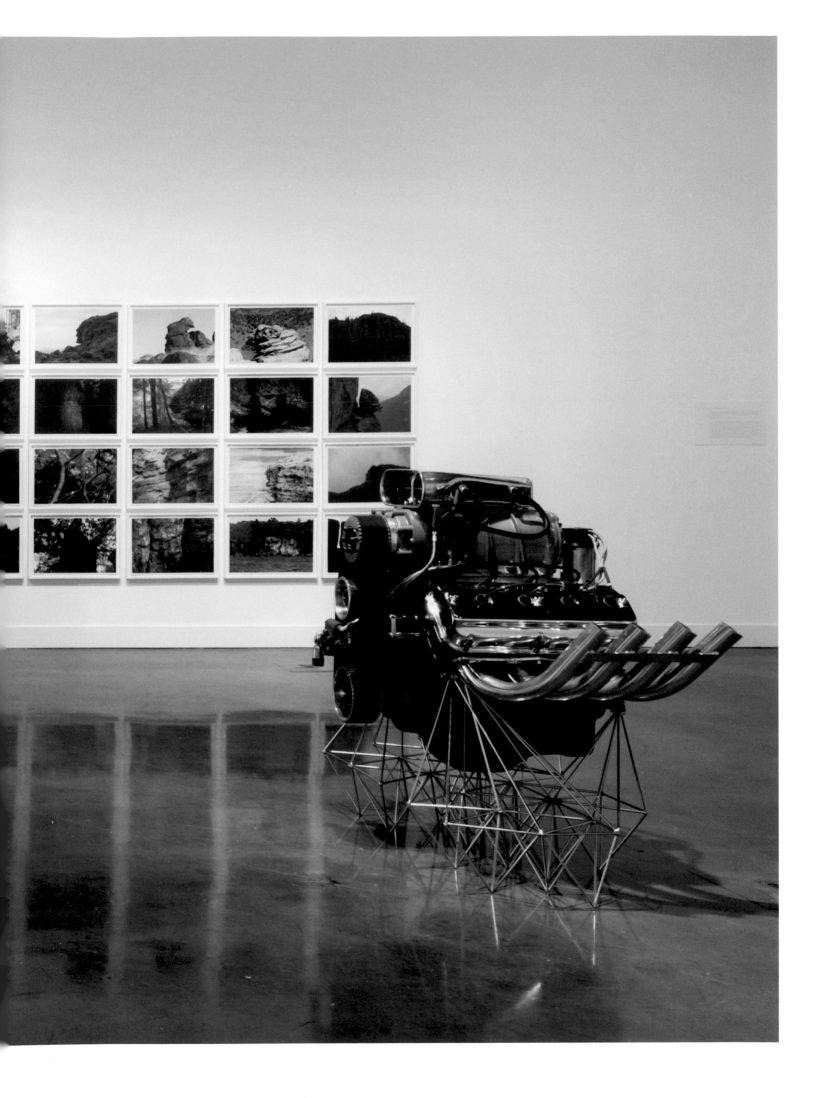

Against the Mythology of Linearity and *Dance of Destruction (featuring "Lady Liberty" as Shiva, Wovoka, Eleanor, and Jim Jones)*

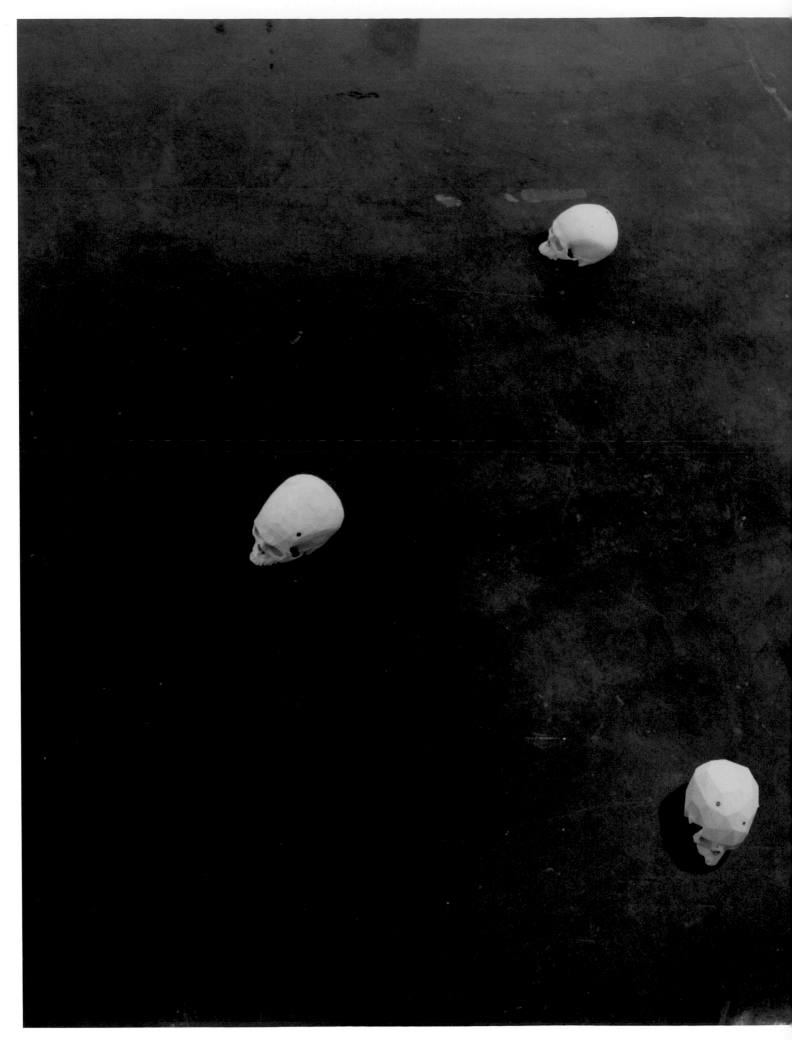

Against the Mythology of Linearity

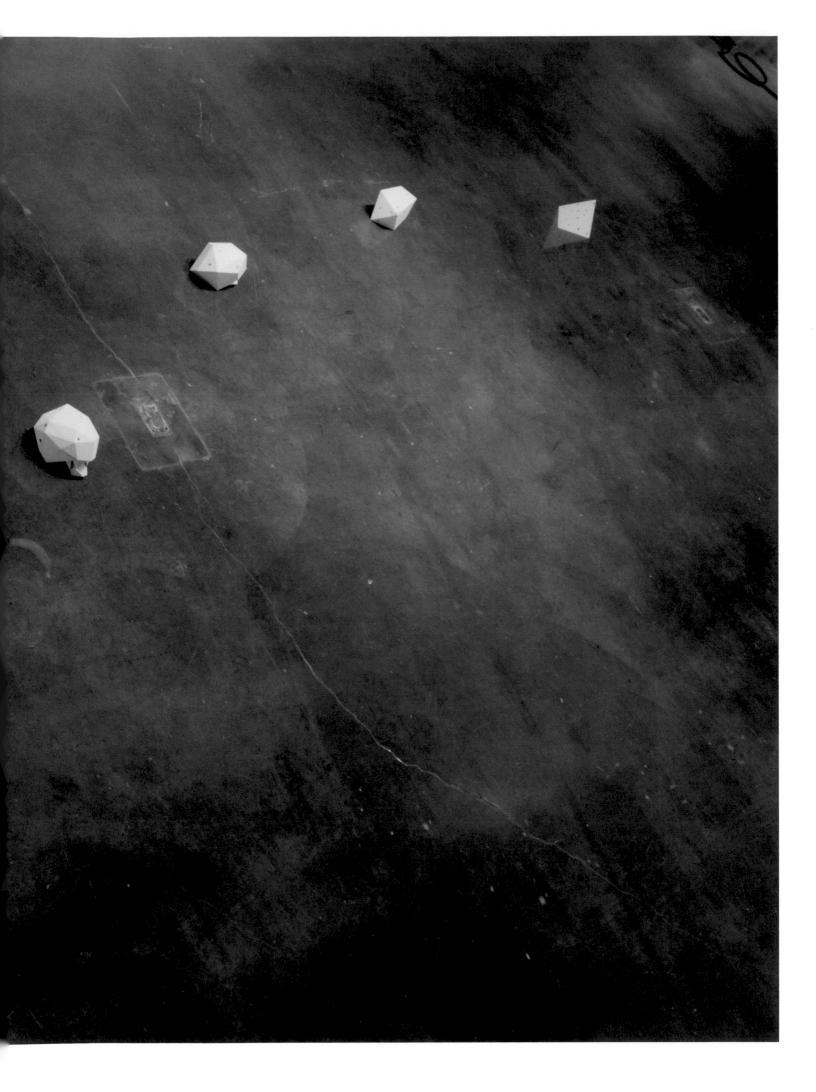

Missing Link and *Against the Mythology of Linearity*

CONTRIBUTORS

BILL ARNING

Prior to becoming the director of the Contemporary Arts Museum Houston in April of 2009, Bill Arning had been the curator at MIT's List Visual Arts Center since April 2000. At the List he co-organized (with Ian Berry) *America Starts Here—Ericson and Ziegler* (2006), which traveled to the Tang Teaching Museum at Skidmore in Saratoga Springs, NY as well as venues in Austin, TX, Kansas City, MO, and Cincinnati, OH. Arning was a member of the *Sensorium* four-person curatorial team that organized MIT's 2006-2007 exhibition, *Sensorium: Embodied Experience, Technology, and Contemporary Art*, which examined how technology has altered the human senses. Arning's exhibitions at MIT also include *Cerith Wyn Evans—Thoughts Unsaid, Then Forgotten…*(2005); *AA Bronson's Mirror Mirror* (2002); and *Son et Lumiére* (2004). Arning contributed essays and artist's interviews for List Center exhibition catalogs, such as Chantal Akerman's first American museum survey, *Moving Through Time and Space* (2008) and *Christian Jankowski–Everything Fell Together* (2006). Arning was the director and chief curator at White Columns Alternative Arts Space, New York, from 1985-1996, where he organized the first New York exhibitions for many significant American and international artists of the period. As a writer on art and culture, Arning's pieces have been published in *Time Out New York*, *Apeture*, *Modern Painters*, *The Village Voice*, *Art in America*, *Trans*, *Out*, and *Parkett*.

DEBORAH G. DOUGLAS

Deborah Douglas, Ph.D., is the Curator of Science and Technology at the MIT Museum in Cambridge, Massachusetts. She has held positions at the National Air and Space Museum, NASA Langley Research Center, Chemical Heritage Foundation, and has taught as an adjunct assistant professor at Old Dominion University. She has organized numerous exhibitions on a wide variety of science and technology topics and created several distinctive new collections in the area of computing, robotics, and calculating instruments. Author of *American Women and Flight since 1940*, she has written numerous essays, articles and reviews about aerospace history.

DAVID MINDELL

David A. Mindell is Dibner Professor of the History of Engineering and Manufacturing, and Professor of Engineering Systems at the Massachusetts Institute of Technology. He is director of MIT's Program on Science, Technology, and Society (STS), and founder and director of MIT's "DeepArch" research group in technology, archaeology, and the deep sea. His research interests include the history of automation in the military, the history of electronics and computing, theories of engineering systems, deep ocean robotic archaeology, and the history of space exploration. His most recent book, *Digital Apollo: Human and Machine in Spaceflight* (MIT Press, 2008) examined the computers, automation, and software in the Apollo moon landings and their effects on human performance. Mindell's previous books include *Between Human and Machine: Feedback, Control, and Computing before Cybernetics* (Johns Hopkins, 2002), and *War, Technology, and Experience aboard the USS Monitor* (Johns Hopkins, 2000), which was awarded the Sally Hacker Prize by the Society for the History of Technology. He is also co-leading a 10- year collaborative project with the Woods Hole Oceanographic Institution and the Greek Ministry of Culture to explore the deep Aegean sea for ancient and bronze-age shipwrecks using autonomous underwater vehicles.

TOM MORTON

Tom Morton is currently a curator at The Hayward Gallery, London, where he has recently organized exhibitions by Cyprien Gaillard, Guido van der Werve, and Tim Lee. He was previously curator of Cubitt Gallery, London, where he organized exhibitions by Charles Avery, Annika Eriksson, Matthew Day Jackson, and his own parents, among others. He organized a special exhibition for the 2007 Athens Biennale (also featuring Jackson), and was co-curator of the 2008 Busan Biennale, South Korea. In 2010, he will co-curate the 7th British Art Show, a five-yearly traveling survey show of contemporary British art. Morton has been a contributing editor of *frieze* magazine since 2003, and also writes regularly for *Bidoun* and *Metropolis M*. He is the author of numerous exhibition catalogue essays on artists including Roger Hiorns, Erik van Lieshout, Pierre Huyghe, Glenn Brown, Andro Wekua, and Victor Man.

DAVID TOMPKINS

David Tompkins is a cartoonist based in Marfa, Texas, where he is a writer and editor for the Chinati Foundation. His forthcoming projects include *Toward Evening*, a 28-page self-published, hand-painted illuminated manuscript. He also makes and distributes free broadsides or "Sunday funnies"—newsprint comic strip handouts that recount the beginning and end of the world according to Norse mythology—with a large cast of "real" and mythological characters. Earlier self-published artist's books include *The Brown Recluse* (2006); *The Big Town* (1996); and *Health 1-5* (1989-1995). Fleabites Press in New York published *And I Saw Edgar Allan Poe* (1997), *Bestiary* (1997), and *Shrive* (1995). Tompkins also drew a continuing comic strip for the *Big Bend Sentinel* newspaper in Marfa from March 2003 to October 2004.

LIST OF WORKS

Against the Mythology of Linearity, 2008
Seven cast skulls: acrylic, abalone, mother-of-pearl
7 x 216 x 72 inches, installed
Courtesy of the artist and Peter Blum Gallery, New York

August 6th, 1945, 2009
Burnt wood and lead
96 x 80 inches
Courtesy of the artist and Peter Blum Gallery, New York

August 6th, 1945, 2008
Burnt wood and lead
80 x 80 inches
Courtesy of the artist and Peter Blum Gallery, New York

Bucky (ROYGBIV), 2007
Intaglio (soft ground and spit bite aquatint), screen-print
24 ¾ x 17 ½ inches, oval sheet
Collection MIT List Visual Arts Center, Purchased with funds from the John Taylor Endowment

Chariot II—I Like America and America Likes Me, 2008
Car frame, steel, wool felt, leather, stained glass, fluorescent light tubes, solar panel, fiberglass, and plastic
48 x 78 x 172 inches
Courtesy of the artist and Peter Blum Gallery, New York

Dance of Destruction (featuring "Lady Liberty" as Shiva, Wovoka, Eleanor, and Jim Jones), 2005
Posters, stickers, photographs, acrylic, pushpins, needlepoint
Approximately 300 inches wide, overall dimensions variable
Courtesy The Saatchi Gallery, London

Heart of Prometheus, 2009
1957 Chrysler Hemi Display Engine built by "Big Daddy" Don Garlits (Nitro/Fuel Supercharged-2500 HP-354 CID-3 15/16" Bore-3 5/8"Stroke, as run in Don Garlits's *Swamp Rat VI-B*), steel, gold plating, brass placard
44 ½ x 48 x 34 inches
Courtesy of the artist and Peter Blum Gallery, New York

Kittinger, 2009
Mirrored box, steel, cedar stump, projector
47 x 35 x 17 inches
Courtesy of the artist and Peter Blum Gallery, New York

Lean-to, 2007
Recycled wall from 2814 Glenview Rd., pillar from Nebraska homestead, bronze, shellac, wool felt, lighting gels, birch tree stump, and framed collage
80 x 168 x 102 inches
Collection of The Blanton Museum of Art, gift of Jeanne and Michael Klein, 2007
[Houston presentation only]

Little Boy and Fat Man, 2009
Two channel B/W DVD
15 minutes
Courtesy of the artist and Peter Blum Gallery, New York

Lonesome Soldier, 2008
Vietnam-era military blankets, rubber, wood, aluminum, plastic
72 x 28 x 16 inches, figure
Collection Florence and Philippe Ségalot, New York

The Lower 48, 2006
Forty-eight photographs, installed in a grid
13 ½ x 20 inches, each sheet; 15 3/8 x 21 7/8 inches, each frame
Courtesy the Steven and Alexandra Cohen Collection

Luminary 1A and Colossus (after Borges and The Library of Babel), 2009
Ten volumes, leather and canvas, oil, dirt, blood, body fluids from the ungloved hands of its viewers over the span of its life as an artwork, gold, stainless steel
24 x 72 x 12 inches, installed
Courtesy of the artist and Peter Blum Gallery, New York

Mapping the Studio (Fat Chance Colonel John Stapp), 2009
Color DVD
12 minutes
Courtesy of the artist and Peter Blum Gallery, New York

Metamorphosis, 2009
Color DVD
20 minutes, 9 seconds
Courtesy of the artist and Peter Blum Gallery, New York

Missing Link (X-Ray), 2008
Eleven photogravures made from x-rays of a sculpture called *Missing Link*
96 x 47 inches, installed
Courtesy of the artist and Grimm Fine Art, Amsterdam

Paradise Now, 2006–2007
Color DVD
15 minutes, 7 seconds
Courtesy of the artist and Peter Blum Gallery, New York

Pilgrimage, 2009
Three channel DVD
Variable timed loops
Courtesy of the artist and Peter Blum Gallery, New York

Matthew Day Jackson and Olivia Fermi
Playing Squash, Los Alamos, New Mexico, April 2009
Color DVD
28 minutes
Courtesy of the artists

Study Collection, 2009
Stainless steel shelves, wood, medical replacement joints, replica
of Phineas Gage's tamping iron, rapid prototype of artist's skull
fused digitally with Phineas Gage's skull, bronze, steel, plastic,
lead, models of the U.S./Soviet nuclear weapons, carbon fiber,
Trinitite
144 x 432 x 17 ½ inches, installed
Courtesy of the artist and Peter Blum Gallery, New York
Special Thanks to Warren Anatomical Museum, Harvard
University

Tensegrity Biotron, 2009
Two-way mirror, mirror, stainless steel, plastic cast bones,
neon light
55 ½ x 52 ¼ x 52 ¼ inches
Courtesy of the artist and Peter Blum Gallery, New York

Matthew Day Jackson and Karen Jackson
Untitled (A Mother's Prayer for Her Son), 2005
Color DVD
13 minutes, 15 seconds
Courtesy of the artist and his mother and the great mystery

Vertigo, 2009
B/W DVD
59 minutes, 3 seconds
Courtesy of the artist and Peter Blum Gallery, New York

MATTHEW DAY JACKSON

Born 1974 in Panorama City, CA
Lives and works in Brooklyn, NY

EDUCATION

2001
MFA Mason Gross School of the Arts, Rutgers University,
New Brunswick, NJ

1997
BFA University of Washington, Seattle, WA

SELECTED SOLO EXHIBITIONS

2009
Douglas Hyde Gallery, Dublin, Ireland
Matthew Day Jackson: The Immeasurable Distance, List Visual Arts
Center, Massachusetts Institute of Technology, Cambridge, MA,
traveled to Contemporary Arts Museum Houston, TX

2008
Drawings from Tlön, Nicole Klagsbrun, New York, NY
Terranaut, Peter Blum Gallery, New York, NY

2007
Diptych, Mario Diacono at Ars Libri, Boston, MA
The Lower 48, Perry Rubenstein Gallery, New York, NY
New Art Dealers Alliance (NADA) in collaboration with Ballroom
Marfa (Marfa, TX), Miami, FL
Paradise Now! (The Salvage), Workspace: Matthew Day Jackson,
Blanton Museum of Art, Austin, TX

2006
Oracle (Days of Future Passed) Mario Diacono at Ars Libri,
Boston, MA
Paradise Now! (Limbo) Cubitt Artists Space, London, UK
Paradise Now! Portland Institute of Contemporary Art, Oregon

2005
Perry Rubenstein Gallery, New York, NY

2004
By No Means Necessary, The Locker Plant, Chinati Foundation,
Marfa, TX

SELECTED GROUP EXHIBITIONS

2008
Art Focus 5, 2008, Jerusalem, Israel
Heartland, Vanabbemuseum, Eindhoven, The Netherlands
*Martian Museum of Terrestrial Art, Mission: to interpret and under-
stand contemporary art,* Barbican Gallery, London, UK
Matthew Day Jackson, Jen Liu, David Maljkovic: The Violet Hour,
Henry Art Gallery, University of Washington, Seattle, WA
The Old, Weird America, Contemporary Arts Museum, Houston, TX
Palimpset, Gallerie Xippas, Paris, France

2007
1st Athens Biennale, Greece
2nd Moscow Biennale, Russia
3rd Beijing Biennale, China
*Huma Bhabha and Matthew Day Jackson: Sculptures and New Print
Editions,* Peter Blum Gallery, New York, NY
Perry Rubenstein Gallery, New York, NY
To Build a Fire, Rivington Arms, New York, NY
Uncertain States of America–American Art in the 3rd Millennium,
Herning Kunstmuseum, Denmark, Centre for Contemporary Art,
Ujazdowski Castle, Warsaw, Poland

2006
25 Bold Moves, House of Campari, New York, NY
Infinite Painting, Villa Manin Centre for Contemporary Art,
Passariano, Codroipo, Italy
Kamp: K48, John Connelly Presents, New York, NY
Mario Diacono Fine Art, Allston, MA
The Searchers, White Box, New York, NY
Time-Based Art is Happening! Portland Institute for Contemporary
Art, Oregon
Uncertain States of America–American Art in the 3rd Millennium,
Museum Center for Curatorial Studies, Bard College, Annandale-
on-Hudson, NY; Serpentine Gallery, London, UK; Reykjavik Art
Museum, Iceland
USA Today, Royal Academy of Art, London, UK
Whitney Biennial, *Day for Night,* Whitney Museum of American
Art, New York, NY

2005
Bridge Freezes Before Road, Barbara Gladstone Gallery, New York, NY
Greater New York, P.S.1 Contemporary Art Center, Long Island
City, NY
Motion, Santa Fe Art Institute, New Mexico
Sticks and Stones, Perry Rubenstein Gallery, New York, NY
*Tony Oursler, Studio: Seven Months of My Aesthetic Education (Plus
Some) NYC Version and Climaxed,* Metropolitan Museum of Art,
New York, NY

The Uncertain States of America–American Art in the 3rd Millennium, Astrup Fearnley Museum, Oslo, Norway
You Are Here, Ballroom Marfa, TX

2004
Drift III, Valentino Pier Park, Brooklyn, NY
Mommy! I! am! not! an! animal!, Capsule Gallery, New York, NY
Relentless Proselytizers, Feigen Contemporary, New York, NY
SuperSalon, Samson Projects, Boston, MA

2003
Biennial, Portland Museum of Art, Maine
Drift II, site-specific exhibition at the former home of Buckminster Fuller, northern New Jersey
K48: Klubhouse, Deitch Projects, Brooklyn, NY
Now Playing, D'Amelio Terras Gallery, New York, NY
Spiritual Hunger, Daniel Silverstein Gallery, New York, NY
White, Black, Yellow, Red, Storefront 1838, New York, NY

2002
Drift, environmental exhibition, Manasquan, NJ

2001
…sorta like a revelation, Rabbett Gallery, New Brunswick, NJ

1999
Sans Titre, Boulder Museum of Contemporary Art, Colorado

SELECTED BIBLIOGRAPHY

2008
"The Lunatic is on the Grass" Graves, Jen. *The Stranger,* 28 Aug. 2008, 22.
Maine, Stephen. "Matthew Day Jackson." *Art in America,* no 10 (Nov. 2008), 180–181.

2007
Cole, Lori. "Omission." Artforum.com (Jan. 2007) www.artforum.com/archive/id=12719.
 "Matthew Day Jackson: Paradise Now! (Limbo)." *Art Review* (Feb. 2007), 159.

2006
Jones, Kristin M. "Matthew Day Jackson." *frieze* (March 2006), 167.
Motley, John. "Matthew Day Jackson." *PICA* (Sept. 2006).

2005
Bae, James. "You Are Here, Ballroom Marfa." *ArtLies,* no. 48 (Fall 2005), 106–7.

Cambourg, Clemence de. "The History Man." *ArtReview,* (Nov. 2005), 34.
Giovannotti, Micaela. "the greater new york 2005." *Tema Celeste,* no. 109 (May/June 2005), 98.
Ho, Christopher K. "In View: Greater New York 2005." *Modern Painters* (May 2005), 105–6.
Kerr, Merrily. "Matthew Day Jackson: Fortunate Son." *TimeOut New York* (Dec. 2005), 119.
Matthew Day Jackson. "Matthew Day Jackson." *V36 Magazine.*
Nickas, Bob. "First Take." *Artforum,* XLIII, no. 5. (January 2005), 155–6.
"Our Selection A-Z," *The Art Newspaper,* no. 157 (Apr. 2005), 2.
Rosenberg, Karen. "Artists on the Verge of a Breakthrough." *New York Magazine,* 7 March 2005, 34–6.
Smith, Roberta. "Spotting an Aesthetic Dispute and Embracing All Sides." *The New York Times,* 17 Dec. 2005, B13.
"Spread Your Wings For Peace: Phoenix," *Village Voice,* L, no. 51, 21–27 Dec. 2005.

2004
Johnson, Ken. *The New York Times,* 6 Aug. 2004, E32.
Levin, Kim. *The Village Voice,* 28 July 2004.

2001
Phillips, Lisa. *New American Paintings: The MFA Annual 2001.* Boston, MA: Open Studios Press, 2001.

RESIDENCIES

2008–09
List Visual Arts Center, Massachusetts Institute of Technology, Cambridge, MA

2006
Portland Institute for Contemporary Art, Oregon

2004
The Chinati Foundation, Marfa, TX

2002
Skowhegan School of Painting and Sculpture, ME

CONTEMPORARY ARTS MUSEUM HOUSTON

This exhibition has been made possible by the patrons, benefactors, and donors to the Museum's Major Exhibition Fund:

MAJOR PATRON
Chinhui Juhn and Eddie Allen
Fayez Sarofim
Michael Zilkha

PATRONS
Mr. and Mrs. A. L. Ballard
Mr. and Mrs. I. H. Kempner III
Ms. Louisa Stude Sarofim
Leigh and Reggie Smith

BENEFACTORS
Marita and J.B. Fairbanks
George and Mary Josephine Hamman Foundation
Jackson Hicks / Jackson and Company
Elizabeth Howard
King & Spalding L.L.P.
Elisa and Cris Pye
Marley Lott
Beverly and Howard Robinson
Swift + Company
The Susan Vaughan Foundation, Inc.

DONORS
Baker Botts, LLP
Bergner and Johnson Design
Citi Private Bank
Julia and Russell Frankel
Jo and Jim Furr
Mr. and Mrs. William Goldberg / Bernstein Global Wealth
Management
Louise D. Jamail
Karol Kreymer and Robert J. Card, M.D.
KPMG, LLP
Judy and Scott Nyquist
Lauren Rottet
David I. Saperstein
Karen and Harry Susman
John and Becca Cason Thrash
Mark Wawro and Melanie Gray
Mr. and Mrs. Wallace Wilson

The Museum's operations and programs are made possible through the generosity of the Museum's trustees, patrons, members and donors. The Contemporary Arts Museum Houston receives partial operating support from the Houston Endowment, Inc., the City of Houston through the Houston Museum District Association, the National Endowment for the Arts, and the Texas Commission on the Arts.

The catalogue accompanying the exhibition is made possible by a grant from The Brown Foundation, Inc.

MIT LIST VISUAL ARTS CENTER

Matthew Day Jackson would like to thank the following people for making this possible:

My loving, inspiring and supportive family, Laura Seymour, Kris Kollmer, Bill Arning, David Tompkins, Tom Morton, Joseph Hung, Olivia Fermi, Dave McDermott, Nick Van Woert, Sean Townley, Amy Reid, Joe Wardwell, Annette Carlozzi, Sara Krajewski, Will Villalongo, Andrew Guenther, Marc Ganzglass, Peter Blum, Mario Diacono, Simone Subal, David Blum, Jorg Grimm, Hannah Reefhuis, Nicole Klagsbrun, Carrie Scott, Ruth Phaneuf, Natalie Campbell, Sylvia Chivaratanond, Philippe Vergne, Amy Davila, Marjory Jacobson, Fritz Margull, Judith Ivry, Paul Fjeld, Crispin Weinberg, Joanna and Peter Ahlberg, Deborah Douglas, Richard Perdichizzi, Jerome Freidman, David A. Mindell, Dominic Hall, Jen Mergel, Erik Ediger, Sharon Jewett, Jane Farver, Barbra Pine, Tim Lloyd, Mark Linga, David Freilach, John Rexine, John Osorio-Buck, Nell Gould, Andrew Neumann, Dirk Adams, Tim Stigliano, Frank Hawley, Don Garlits, Lenders to the exhibition (Saatchi Gallery, Steven and Alexandra Cohen Collection, Philippe Segalot, The Blanton Museum of Art), MIT Energy Initiative, Richard Amster, MIT Dept. of Facilities, Eric Beaton, Ron Adams, Joe Gifun, Zapotec Energy Cambridge, Paul Lyons, Krypton Neon/Kenny Greenberg, Tom Unger, Solid Concepts, Direct Dimension, Los Alamos YMCA, MIT Museum, MIT Energy Initiative, Warren Anatomical Museum at Harvard University, MIT Draper Laboratory, Contemporary Arts Museum Houston, Toby Kamps, Tim Barkley, Jeff Shore, Kenya Evans, Bret Shirley, Cheryl Blissitte, Connie McAlister, Paula Newton, Justine Waitkus, Karen Soh, Henry Art Gallery, Richard Manderbach, Jeff Collum, Jim Rittiman, Sallie-Jo Wall, Owen Santos, Silicon Energy, Gary Shaver, NASA, Frank Hawley Drag Racing School, NHRA, The Great Mystery, and Punkin (aka "Beast").

• • •

I had been following the Neutron Trail, visiting places which speak to us now about the legacy of my grandparents Laura and Enrico Fermi. When Matt proposed a squash game between himself and a Fermi descendant, I was shocked and delighted. His playful and meaningful diversion—so in the Enrico spirit! Random collisions of the ball and racquet, the ways we picked up the game when the volley disintegrated—all wonderfully symbolic. Playing squash with Matt has quickened my own journey and for this I am grateful.

—Olivia Fermi, M.A. A.B.S., ConRes Cert

This publication accompanies the exhibition
Matthew Day Jackson: The Immeasurable Distance

MIT List Visual Arts Center
May 8–July 12, 2009

Contemporary Arts Museum Houston
October 17, 2009–January 17, 2010

Support for the presentation of *Matthew Day Jackson: The Immeasurable Distance* at the MIT List Visual Arts Center has been made possible by the Council for the Arts at MIT and the Massachusetts Cultural Council. Special thanks to the Peter Blum Gallery, New York, NY and Phoenix Media/ Communications Group.

Essay © Bill Arning
Essay © Deborah Douglas
Essay © David Mindell
Essay © Tom Morton
"Project of Bird" © David Tompkins

Photography by Tim Lloyd, MIT List Visual Arts Center, unless noted otherwise:
Page 34 by Deborah Douglas
Page 43 by Peter J. Ahlberg
Video stills courtesy of Joseph Hung

Catalogue design by Peter J. Ahlberg / AHL&CO
Color separations by Tucker Capparell
Printed and bound by Shapco, Minneapolis, Minnesota
Library of Congress Control Number: 2009929273
ISBN 978-1-933619-21-7